●

FLOWER DRAWINGS

This handbook illustrates a selection of drawings of flowers from the collection at the Fitzwilliam Museum. The book is arranged chronologically and ranges from the fifteenth century to the present day. Beginning with illustrations in the borders and backgrounds of illuminated manuscripts, the selection traces the genre through attempts at accurate delineation of form in the Renaissance and the more scientific approach of the later seventeenth and early eighteenth centuries. It concludes with contemporary examples to show that the tradition continues. The illustrations bring out the stunning detail and colour of the originals.

FITZWILLIAM MUSEUM HANDBOOKS

FLOWER DRAWINGS

DAVID SCRASE

KEEPER OF PAINTINGS, DRAWINGS
AND PRINTS, FITZWILLIAM MUSEUM
PHOTOGRAPHY BY ANDREW MORRIS

CAMBRIDGE
UNIVERSITY PRESS

PUBLISHED BY THE PRESS SYNDICATE OF THE UNIVERSITY OF CAMBRIDGE
The Pitt Building, Trumpington Street, Cambridge CB2 1RP, United Kingdom

CAMBRIDGE UNIVERSITY PRESS
The Edinburgh Building, Cambridge CB2 2RU, UK http://www.cup.cam.ac.uk
40 West 20th Street, New York, NY 10011–4211, USA http://www.cup.org
10 Stamford Road, Oakleigh, Melbourne 3166, Australia

First published 1997
Reprinted 1998

Printed in the United Kingdom at the University Press, Cambridge

Typeset in Quadraat 9.5/13.75pt, in QuarkXpress™ [TAG]

A catalogue record for this book is available from the British Library

ISBN 0 521 58463 9 hardback
ISBN 0 521 58578 3 paperback

CONTENTS

Introduction 1

INTRODUCTION

The origins of still life painting can be traced back to antiquity but in the West it was only in the sixteenth century that it became acceptable as an art form in its own right. Before then flowers had appeared regularly as part of the decoration in the borders of medieval manuscripts, most notably of the Flemish and Burgundian Schools, culminating in the workshop of Jean Bourdichon. The illuminators can be exquisite in their rendering of floral detail (1–3) and attention to accurate delineation of the plants is juxtaposed with sensitive placing of them on the page. The illustration of herbals likewise contained drawings of plants which had particular pretensions to botanical accuracy.

A few individual artists, like Leonardo da Vinci and Albrecht Dürer, surpass the miniaturists in the accuracy of their drawings from nature. Leonardo's botanical drawings (mostly to be found in the Royal Collection at Windsor) show considerable understanding of plant structure and habit, while Dürer's watercolours of flowers and grasses (Albertina, Vienna) are amongst the most beautiful of all his work; both artists' botanical work looks strikingly modern. Still life painting in oils does not survive much before the mid-century, but a detail like the pots of lilies and iris in the foreground of Hugo van der Goes' Portinari altarpiece (Uffizi, Florence), completed c.1479 and Memling's *Marian flower piece* (Thyssen-Bornemisza Collection, Madrid) on the *verso* of a portrait of a *Young man at prayer*, give an idea of what Erasmus, who died in 1536, must be referring to in his *Colloquies* about the pleasure to be derived from comparing real with painted flowers. He adds that the painting holds fresh and green all the winter when the flowers are dead and withered. This sentiment gives additional insight to the reason for painting flower-pieces aside from for the intrinsic allegorical meaning they contain: that all life is fragile and death comes to all.

So far as botanical drawings are concerned the tradition of the illuminator merged with the scientific quest for accuracy implicit in the illustrators of the herbals, and resulted in the late sixteenth century in a series of beautiful watercolours usually executed for wealthy or aristocratic patrons. Notable amongst those whose work has survived are Jacopo Ligozzi who worked for the Medici in Florence, Georg Hoefnagel, who worked for Rudolf II of Prague, and Jacques Le Moyne de Morgues, a Huguenot, who fled Paris at the time of the St Bartholomew Massacre (1573) for London. To them can now be added

Antoine du Pinet de Noroy (4), the earliest of the botanical draughtsmen represented in the Fitzwilliam. These artists head a tradition which continues to this day.

In the seventeenth century one of the main centres of flower drawing was Paris, where Nicolas Robert's work (7–9) inspired Louis XIV to commission a series of botanical paintings on vellum, known as Les Vélins du Roi. Robert painted twenty of these a year for the King, a tradition maintained by his successors, including Claude Aubriet (15). These vellums are still kept at the Jardin des Plantes in Paris. Other centres of importance for botanical drawing were Frankfurt and Holland, where tulip books (5), with drawings tantamount to advertisements, were the forerunners of the seedsmen's catalogues. It is odd that in England, where at this time important contributions to botany and science in general were being made, no native artists specialising in flower painting appeared apart from Alexander Marshall, whose work can be seen at the British Museum and at Windsor.

The most important flower painters in oil at the beginning of the century were Jan Brueghel in Antwerp, Jacques de Gheyn at The Hague, Ambrosius Bosschaert, who left Antwerp for Middelburg and Georg Flegel, who worked for many years in Frankfurt. It was in Frankfurt that the most interesting of the women engaged in botanical drawing was born, Maria Sibylla Merian (12). Merian led an unusual and exciting life, travelling to Surinam (that part of South America later known as the Dutch, French and British Guianas) to pursue her botanical and entomological studies. Her published works revolutionised the sciences of zoology and botany and laid the foundations for the classification of plant and animal species by Charles Linnaeus in the eighteenth century.

Merian died in 1722, a forerunner of the many distinguished women artists who found it possible to make careers as professionals in this restricted area of painting. Foremost amongst these were the Dietzsch sisters (19, 20), known particularly for painting on a dark ground. They worked in Nuremberg which became an important centre for botanical art, thanks in large part to the patronage and enthusiasm of the physician, Dr Christoph Jakob Trew. He helped the young Georg Ehret (21–6) at the beginning of his illustrious career. Ehret, possibly the finest botanical draughtsman of all, was much influenced by Linnaeus' ideas and put into practice his way of classifying plants (25). Although born in Germany, the son of a gardener, it was in England that

Ehret's career came to full fruition. He worked for a series of fashionable patrons, including the President of the Royal Society, Sir Hans Sloane, the Royal Physician, Dr Meade, and Margaret, Duchess of Portland, and lived in England from 1736 to 1770. Ehret's influence was widespread through the coloured engravings issued after his drawings during his lifetime. Most of the hundred drawings in the Fitzwilliam by him are on vellum but there is one drawing on paper (23), inserted in a *florilegium* by the Bath artist, Thomas Robins the Elder (1716–70). The drawings in this album (28, 29) are all done from nature and were the basis of more formal paintings intended for exhibition and sale (27).

One of the reasons for the great importance of botanical drawings was that often botanists had nothing but a dried specimen from which to attempt to classify a plant. Not every expedition could employ a trained draughtsman to join them in the field. Artists like Ehret could reconstitute the appearance of the flower in its prime using the specimen and sometimes a sketch done on the spot by an amateur draughtsman. Of course, this could result in a slight distortion of the plant in its depiction and this may explain why it is sometimes difficult to be a hundred per cent certain of the correct botanical name which should be attached to some of these early drawings. Accurate drawing was very important, but the best artists used their judgement in the positioning of the plant on the page to its best effect, to create an artistically and aesthetically pleasing composition. Ehret was a prime exponent of this, but so too were Robins, Sowerby and Redouté.

In the later eighteenth century several women exhibited publicly at the Royal Academy in England and the Salon in France. The first woman to have a professional career as a flower painter in Britain was Mary Moser (1744–1819), (32). She was a founder member of the Royal Academy in 1768 and decorated a room at Frogmore in Windsor Park for Queen Charlotte. A direct contemporary, in France, Anne Vallayer-Coster (1744–1818), was appointed painter to Queen Marie-Antoinette (33). Comparison of their work shows a completely different attitude to flower drawing: Mary Moser is more concerned with dramatic presentation in the Dutch tradition, whereas Anne Vallayer-Coster is more interested in a painterly approach to her subject, ultimately inspired by Chardin.

Apart from the career-women, the late eighteenth and early nineteenth centuries are remarkable for the number of first rate lady amateurs. Elizabeth Burgoyne (35), Amelia Fancourt (37), Mary Compton, Countess of Northamp-

ton (38) and Lucy Cust (52) are all fine practitioners, worthy of public exhibition alongside the best of the professional males, James Sowerby, who founded the *Botanical Magazine* (40, 41), and the Austrians, Francis and Ferdinand Bauer (44, 45). The Bauers were phenomenally gifted and both were extremely precocious. Francis had the fortune to come to the attention of Sir Joseph Banks, the President of the Royal Society, who arranged for him a permanent job as draughtsman to the Royal Gardens at Kew, where he worked for nearly fifty years. Patronised by the Royal family (Queen Charlotte was one of his pupils), he was unusual in having a secure position all his adult life. His younger brother, Ferdinand, no less gifted a draughtsman, had a more adventurous career. He travelled in the Aegean with John Sibthorp, Sherardian Professor at Oxford University and to Australia on Matthew Flinders' five year journey of exploration. On his return to England, he was unable to find financial support for the publication of the Australian plants he and Robert Brown, the botanist, had discovered, so he went back to his native Austria.

Whilst England remained a leader in the field in the nineteenth century the French school, dominated by the example and pupils of Pierre-Joseph Redouté (1759–1840) reasserted itself. Redouté himself, who had the distinction of working for both Marie-Antoinette and the Empress Josephine, has a justly won reputation (42, 43). At his best he is the equal of Ehret and, like him, knowledge of his work was spread by coloured prints and lavishly produced books based on his watercolours. The finest of his drawings were those made for the Empress in which he recorded the rare plants she grew in the gardens at Malmaison. He is best known for the coloured engravings of *Les Liliacées* and *Les Roses*, published respectively in 1802–16 and 1817–24. After Napoleon's fall Redouté continued to have a fashionable career, working at the Jardin des Plantes and teaching public courses and private pupils, like the two daughters of the Duc d'Orléans, the Princesses Louise and Marie. Towards the end of his career his style hardened and several of his late works have a mechanical appearance. Despite his reputation and skill, Redouté was prodigal with his money and he died in poverty. He had many pupils of varying degrees of excellence and several drawings are known in which the pupil copies the master; Nathalie d'Esménard's *Noisette Rose* (53) is a characteristic example. Redouté's modern reputation may outflank his contemporaries, but in his day several artists fought him for the palm, amongst them his pupil, Pancrace Bessa (48). The nineteenth century saw Lyons assert itself as a centre

of flower painting, represented here by Antoine Berjon (39) and Dominique Dumillier (61).

In England the juxtaposition of professional and amateur continued, with several of the women, Mrs Withers (59) for example, achieving a more consistent standard of excellence than the men. Whilst the interest in accurate delineation of exotic species continued (orchids by Cornelius Durham (58) and the Gymea Lily by John Lindley (54) are examples of this tradition), a more 'Romantic' pictorial approach is found in the work of Charles Rosenberg (57) and his sister, Mrs William Duffield (60) and, on the Continent in that of W. Mussill (62).

The twentieth century has seen both these strands continue. Although represented by a finely botanical drawing of an Antirrhinum (63), Raymond Booth is best known for his imaginative naturalist paintings, whereas Margaret Stones (64) has a justly deserved reputation as guardian of the grand tradition of botanical drawing, commensurate with Nicolas Robert, Georg Ehret and Pierre-Joseph Redouté. These two artists show that there is still a lively interest in the work of, and a practical need for, botanical draughtsmen and they exemplify the equal brilliance in this area of expertise of both men and women.

The Fitzwilliam's collection of flower drawings owes its importance to the bequest in 1973 of Major the Hon. Henry Rogers Broughton, 2nd Lord Fairhaven. Major Broughton had already given a splendid group of thirty-seven flower paintings to the Museum in 1966. At his death these were enriched by a further eighty-two oil paintings, including examples by Jan Brueghel and Jan van Huysum. In addition to these were about nine hundred drawings of flowers on paper and vellum and thirty-eight albums in which were found many of the most important drawings included in this selection. With so increased a richness of quality and variety to what little the Fitzwilliam already possessed in this area (scattered examples by Ehret, Merian, Margaret Meen and one each by Redouté and Cézanne), the museum became overnight one of the principal repositories in Europe. Although there are lacunae, Leonardo, Dürer, Hoefnagel, Ligozzi and Le Moyne de Morgues have already been mentioned, similarly there are no flowerpieces by the great nineteenth-century exponents, Delacroix, Fantin-Latour, Courbet, Odilon Redon and Manet. But, as happens so often to the rich, greater riches are

given, and the museum was presented with a splendid example of Margaret Stones' draughtmanship by John McIlhenny in 1989 (64), and, most recently, Her Majesty's Government allocated to us the ravishing book (4) made for Louise of Lorraine by Antoine du Pinet in 1575 from the collection at Wrest Park, thus providing us with a natural link between the decorations in Medieval Books of Hours and the scientific drawings of the seventeenth century.

The initial botanical identification of these drawings was done by John Raven, who was elected Honorary Keeper of the Broughton Collection. Other botanists who have helped with identification of species include Peter Yeo and Clive King, Dr John Dransfield and Dr Martyn Rix. The basic work on biographies and measurements has been done by a series of volunteers, foremost amongst them Mrs Vivian Tubbs.

In making the selection for this handbook three criteria have been foremost: historical continuity, variety of artists and quality. Many of the drawings illustrated are bound in albums, which can only be exhibited a page at a time and thus are rarely seen by the public. This explains the extraordinary condition of much of the Broughton Collection and the brilliance of the colour of the drawings. Indeed, in a book like this, one is able better to savour the range of the collection than in an exhibition.

The drawings are mostly executed in watercolour or bodycolour (pigment to which white is added to make it opaque), sometimes with the addition of gum arabic, a natural resin which imparts a rich gloss to a colour and enhances the tonal quality of the darker areas, over an outline drawing in graphite. Many are on prepared vellum, which gives an especial lustre to the surface effect of the pigment. The measurements are in millimetres (apart from 1–3) and are given height before width.

The best introduction to the history of botanical drawing is Wilfred Blunt's *The art of botanical illustration*, London, 1950, enlarged by William Stearn, Collins 1994 and reissued in larger format. Ehret is treated handsomely in Gerta Calmann's *Ehret – painter extraordinary* and Redouté, most recently by Martyn Rix with William Stearn in *Redouté's fairest flowers*, The Herbert Press/The British Museum (Natural History). Martyn Rix's *The art of the botanist*, Lutterworth Press, 1981 and Lys de Bray's *The art of botanical illustration*, The Wellfleet Press, 1989, are also good introductions to much of what is

abbreviated here. For botanical information fundamental are *The Royal Horticultural Society's garden encyclopaedia of plants and flowers*, the Readers Digest *Encyclopaedia of garden plants and flowers* and Hilliers' *Manual of trees and shrubs*, David and Charles. *The plant finder*, published in association with the Royal Horticultural Society is also useful.

The photographs were taken by Andrew Morris, Chief Photographer at the Fitzwilliam Museum. At the Cambridge University Press Josie Dixon and Victoria Sellar have been unfailingly helpful. I was much helped in my unreasonable demands for immediate response by Georgie Wolton. I would also like to mention the help I received from Rosalind Savill, Dr John Brown, and Alexandra Boyle. Eleanor Smith corrected my text, put it in recognisable and disciplined order, and compiled the list of contents. Bryan Clarke gave technical advice on media. All of them I should like to thank.

DES PROPRIETEZ DES CHOSES

A translation of Bartholomaus Anglicus'
De proprietatibus rerum, made by Jean Corbechon
at the command of Charles V of France.

◆

Vellum. 40.5 × 28.5 cm. 363 folios.
Produced c.1415 in France. Probably made in the
workshop of the Master of the Hours of the Maréchal de
Boucicault. Given by Brigadier Alexander Stirling
of Keir, 1897. **MS.251 folio 135**.

The background is sown with lilies, presumably as a compliment to Amadeus VIII of Savoy, who used the lily as an emblem and for whom it is likely that this manuscript was made. The quality of draughtsmanship is extremely high and the artist responsible for the illumination must have studied the lilies from life to be able to delineate their form so accurately. The lily is perhaps the flower most frequently depicted in early manuscripts, largely because of its association with the Virgin Mary and in particular with the Annunciation.

The scene shows a lecturer holding a gold armillary sphere and giving a lecture to his pupils.

comme il apptient a ceste pnte euure
et atant fine le bñe liure des propse
tez des choses

Cy commence le bñe liure des pro
prietez qui parle et tracte du monde
et des corps celestieulx Et ne vueil

HORAE
BOOK OF HOURS

—

Vellum. 11.3 × 7.9 cm. 196 folios.
Produced in the fifteenth century, probably in Bruges.
Bequeathed by Frank McClean, 1904. **McClean**
MS.93, folios 152 verso, 159 verso.

Written in Dutch, the upper miniature shows Livinus, Bishop and Martyr, who was ordained at Canterbury by St Augustine and was martyred in 657. His relics were brought to Ghent in 1007. He is holding his attribute of a pair of pincers with a de-racinated tongue, surrounded by a border of heartsease and speedwell, with butterflies and moths.

The lower miniature shows St Barbara reading beside the tower in which she was imprisoned, surrounded by a border of pinks, one growing from a wicker basket, with a snail crawling up the stem, the others flowering free, with a spider, butterflies and moths.

This sort of border decoration reached its greatest perfection in the Books of Hours produced in France in the workshop of Jean Bourdichon (1457–c.1521). The quality of these Flemish Hours is not as exquisite as those, but the idiom is the same and considering the small scale of this particular book the execution is crisp and delicate, with the flowers showing evidence of having been studied from nature.

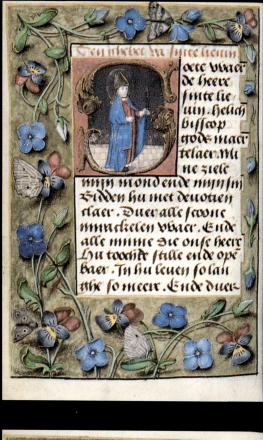

Een ghebet va̋ sinte lieuin

oet waer
de heere
sinte lie
uin. helich
bisscop
gods maer
telaer. Mi
ne ziele

mijn mont ende mijn si
Bidden hu met deuotien
claer. Duer alle scoene
muactelen waer. Ende
alle minne die onse heer
hu tooghde stille ende ope
baer. In hu leuen solan
ghe so meerr. Ende duer

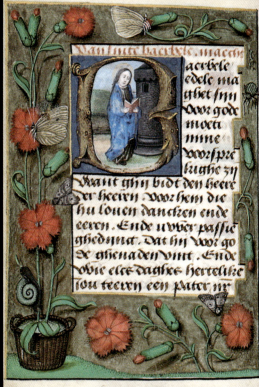

Van sinte baerbele. maecht

acrbele
edele ma
ytbet sijn
voor gode
moeti
minne
voorspre
kughe zij
want ghi bidt den heere
der heeren. voor hem die
hu louen dancken ende
eeren. Ende u ver passie
ghedijnt. Dat hi voor go
de ghenaden vint. Ende
wie elcx daghes hertelike
jou teeren een pater n̄

HORAE
BOOK OF HOURS

—

Vellum. 16.7 × 12 cm. 119 folios +7.
Produced in 1526 in Flanders. The text written
by Sister Gertrude van Doetinchem. Bequeathed by
Frank McClean, 1904. **McClean MS.99**
folios 11 verso and 12 recto.

Written in Dutch, the miniature shows the frontispiece to the Hours of the Virgin, with Mary seated, reading, within a *hortus conclusus*, a unicorn, tamed by her virginity, by her side. Outside the perimeter of the walled garden (another symbol of Mary's virginity) is the Angel of the Annunciation, blowing a horn and holding two hounds, which strain at their leashes. In the background can be seen God the Father, looking on from behind a burning bush. The border is decorated with highly stylised flowers: pinks, thistles, borage, forget-me-not, pansies, peas, strawberries, roses and daisies.

Although painted with considerable charm, there is a naïvety in the handling of the flowers in the border which shows a lack of true understanding of the underlying form of the blossoms. In particular the rose and the daisies are formulaic, as are the moths and butterflies. By 1526 printing had largely superseded manuscript for this type of book and in the painting of the borders in particular, it is obvious that this is the end of a tradition, lacking in vitality, albeit efficient in its decoration.

This particular book belonged to Jutta van Doetinchem (presumably a relation of the scribe) and an inscription in Dutch at the front states that 'Money for a drink penny will be provided to the finder and returner of the book if lost.'

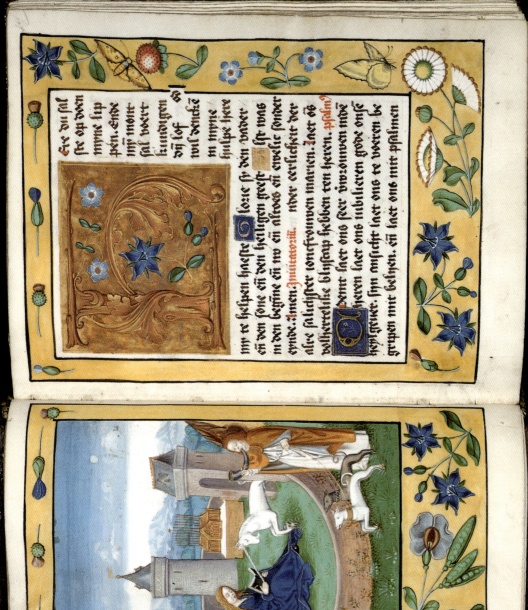

4

ANTOINE DU PINET
DE NOROY

Born at Besançon, died c.1584 Paris

—

NARCISSUS PSEUDO-NARCISSUS
L. (DAFFODILS)

Watercolour over graphite on paper, framed by a border of gold paint.
204 × 139 mm. From an album containing a dedicatory sonnet and 48 drawings,
55 folios. Accepted in lieu of Inheritance Tax by H.M. Government and allocated
to the Fitzwilliam Museum from the collection of Baroness Lucas of
Crudwell and Dingwall at Wrest Park, 1994.
PD.217–1994, folio 29.

The album was made to celebrate the arrival in France of Louise of Lorraine (1553–1601) on the occasion of her marriage in 1575 to Henri III of France. The original gold-tooled limp vellum cover bears her arms. The dedicatory sonnet, which alludes to the hope that the Queen will be fruitful like the flowers and fruit contained within the book, is signed with the initials 'A.P.'. This has led to the drawings it contains being attributed to Antoine du Pinet.

Du Pinet (or du Pinay) was known as a competent draughtsman and the author of several books, including an *Historia plantorum*, published in Lyons in 1561.

The format of the book and its dedicatory sonnet parallel the well-known work by Jacques Le Moyne de Morgues (1530–88), whose book of flower drawings in the British Museum, signed and dated 1585, likewise incorporates a sonnet. Le Moyne was a Huguenot who left France in 1572 and thus would not have been available to pay this compliment to the new Queen of France. His work is more botanically precise than du Pinet.

The daffodils are shown full frontal, full back, and in profile to right, both in bud and in bloom, as they are also shown in Le Moyne's drawing of the same flower in the Victoria & Albert Museum.

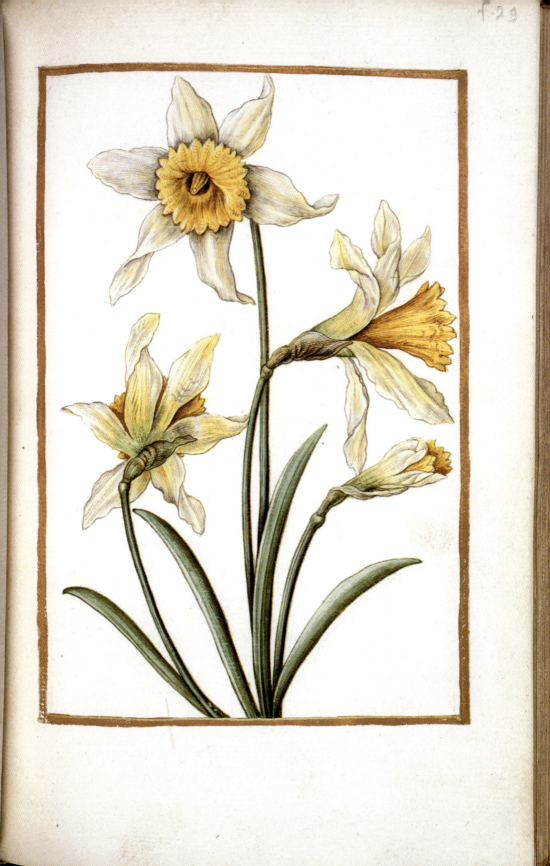

AMBROSIUS BOSSCHAERT
THE YOUNGER

Middelburg 1609–1645 Utrecht

◦

TULIP

Watercolour over graphite on paper. 300 × 186 mm.
From an album containing 65 drawings of tulips, in an old red morocco
binding bearing the arms and cipher of Queen Anne used between 1702 and 1707.
Bequeathed by Major the Hon. Henry Rogers Broughton, 2nd Lord Fairhaven,
1973. PD.123–1973, folio 44 (numbered 47).

Ambrosius Bosschaert the Younger was the eldest of the three sons of Ambrosius Bosschaert the Elder (1573–1621) and Maria van der Ast. Both parents and all three sons were flower painters. The family moved from Middelburg to Utrecht in 1621.

Folio one of this tulip book has a signature which has been read as 'A Bosschaert'. Too few drawings of the Bosschaert family have survived for it to be possible to be certain that these are by Ambrosius the Younger rather than his younger brother, Abraham (c.1613–43). Ambrosius was considered the more talented of the two and as the quality of the drawings in the album is consistently good, it seems appropriate to attribute them to him.

The tulip, identified as an *Olinda*, is of the type known as a 'broken tulip'. The streaks of white in this originally red tulip are a symptom of infection with tulip-breaking virus. Such tulips were highly regarded, particularly in Holland in the early seventeenth century, where they were assiduously cultivated and appeared regularly in contemporary flower paintings.

Tulip books were forerunners of the seedsmen's catalogues and were very popular during the period of 'tulipomania', when collectors and gardeners sought the rarest blooms and bulbs could change hands at colossal prices. The search for the 'black' tulip epitomises this period, which ended with a collapse of the market in 1637.

47.

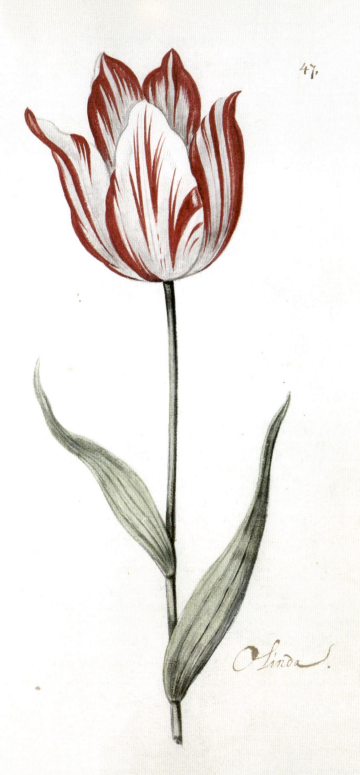

Olinda.

JACOB MARRELL

Frankenthal-am-Rhein 1614–1681 Frankfurt

—

AN OPEN WICKER BASKET OF
FLOWERS IN A WINDOW EMBRASURE,
WITH A FROG AND INSECTS

Bodycolour and watercolour, with scraping out on vellum.
276 × 375 mm. Signed and dated, lower right: 'JACOBUS MARRELLUS
f. A.1634' Bequeathed by Major the Hon. Henry Rogers Broughton,
2nd Lord Fairhaven, 1973. **PD.796–1973.**

Jacob Marrell was a pupil of Georg Flegel (1564–1638) in Frankfurt, but later moved to Utrecht where he studied in the 1630s with Jan Davidsz. de Heem (1606–83/4). His second wife was the mother of Maria Sibylla Merian (1647–1717) whom Marrell was to teach. Between 1637 and 1646 he produced a *Tulpenboek* for a Portuguese flower grower who lived near Utrecht. Marrell provides a link between the Bosschaert tradition and that of the Flemish masters Brueghel and Seghers. His work is praised by his contemporary, Joachim Sandrart, in his *Teutsche Academie*.

The drawing is done on a leaf from an old chorale, which has been scraped down. The flowers include nigella, a series of broken tulips, auriculas, anemones, jasmine, roses, borage, forget-me-not and violas. The insects, which are delineated with great accuracy, include ants, beetles, a spider and a European toad.

The drawing is one of a pair, and is a characteristic example of Marrell's drawings on vellum. The composition derives from the work of Jan 'Velvet' Brueghel (1568–1625) and the high degree of finish and the date and signature show that it was the sort of drawing intended to be displayed on the wall as if it were a painting on panel.

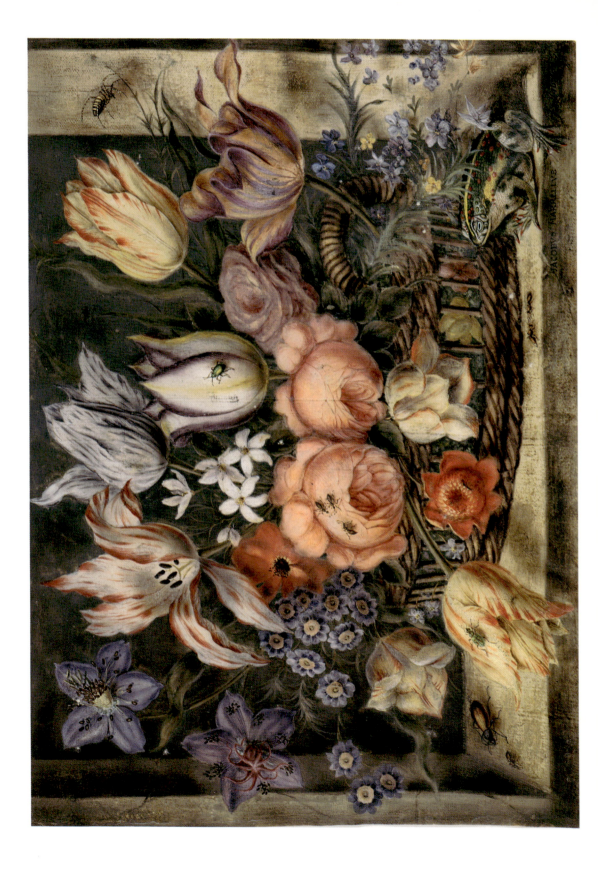

NICOLAS ROBERT

Langres 1614–1685 Paris

—

THREE BROKEN TULIPS

Bodycolour and watercolour over graphite on prepared vellum,
framed by a border of gold and reddish brown paint. 300 × 223 mm.
From an album of 62 drawings on vellum, tipped onto eighteenth-century paper.
The binding in red morocco, with clasps, engraved with a stylised tulip,
the spine lettered in gold : MIGNA/TURES. Bequeathed by Major the
Hon. Henry Rogers Broughton, 2nd Lord Fairhaven, 1973.
PD.109–1973, folio 14.

Nicolas Robert was the son of an innkeeper; nothing is known of his early training. His name first occurs as the illustrator of a small book of etchings of flowers, *Diversi fiori*, published in Rome in 1640. In 1641 he was commissioned by the Baron de Sainte-Maure to illustrate a book of flowers, the *Garlande de Julie*, to honour de Sainte-Maure's fiancée, Julie d'Angennes. The charm of Robert's contribution was noticed by Louis XIII's brother, Gaston d'Orléans, who commissioned from Robert a pictorial record of the flowers and animals kept in his gardens and private zoo at Blois. At Gaston's death in 1660 these drawings passed to Louis XIV. To these beautiful drawings, known as *Les Vélins du Roi*, the King added twenty each year, a tradition continued by the Bourbon monarchs until the French Revolution. These drawings are now in the Museum of the Jardin des Plantes, Paris. In 1664 Robert was appointed 'Peintre ordinaire de Sa Majestie pour la Miniature', which explains the title on the spine of the bound volume. He was selected by the newly founded Académie Royale des Sciences to illustrate a history of plants, published posthumously in 1701, although a preview, Dodart's *Mémoires pour servir à l'histoire des plantes*, appeared in 1675. Robert is considered the finest of the French flower painters.

The *mise-en-page* is exceptional and conveys the Baroque swagger of these spectacular broken tulips as well as their bold striation. Drawn with the tip of the brush, they are exquisite in their realisation of the texture of the petals, which is enhanced by the use of prepared vellum, a technique which provides a particular gloss to the surface effect.

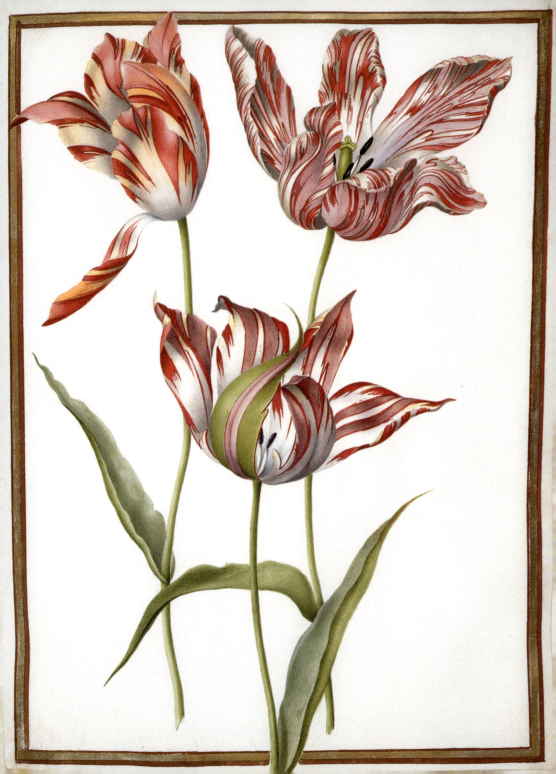

NICOLAS ROBERT

Langres 1614–1685 Paris

—

SIX DIVERSE FLOWERS WITH AN
INSECT AND A TROPICAL BUTTERFLY

*Bodycolour and watercolour with gold over graphite on prepared
vellum, framed by a border of gold and reddish brown paint. 320 × 226 mm.
From an album of 62 drawings on vellum. Bequeathed by Major the Hon.
Henry Rogers Broughton, 2nd Lord Fairhaven, 1973.*

PD.109–1973, folio 43.

Arranged on the page as if it were a florilegium, the flowers are identified by the French inscriptions in gold paint, from left to right: Bouillon blanc (Verbascum); *Grenadier simple* (double pomegranate); *Rose incarnatte* (carnation-coloured rose); *Martagon* (martagon lily); *Muscari à fleur bleue* (blue grape hyacinth); *Petit laurier-rose* (small rose bay; oleander). The martagon is better known as a Turk's-cap lily.

There are several sheets in the album which are arranged in this manner, with a group of disparate flowers identified by inscriptions. It recalls the traditional arrangement of the 'florilegium', or anthology of flowers. Painted in the same technique as the tulips, their execution is a little drier, not quite so exquisite; but there is no reason to doubt that the bulk of them were also painted by Robert himself. A very few pages are altogether more coarse and were probably produced by one of his followers.

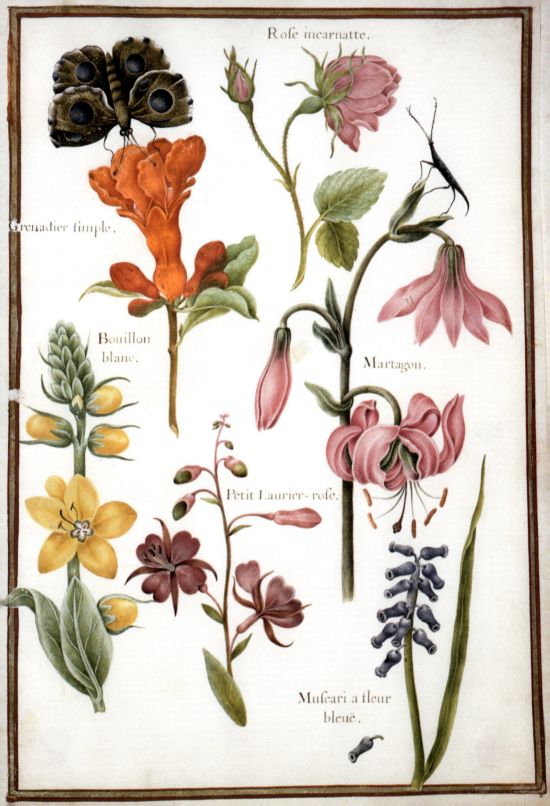

Rose incarnatte.

Grenadier simple.

Bouillon
blanc.

Martagon.

Petit Laurier-rose.

Muscari a fleur
bleuë.

NICOLAS ROBERT

Langres 1614–1685 Paris

◦

ROSE AND LAVENDER WITH BIRDS
AND A BUTTERFLY

Bodycolour and watercolour on prepared vellum,
framed by a border of gold and reddish brown paint. 306 × 220 mm.
From an album of 62 drawings on vellum. Bequeathed by Major the
Hon. Henry Rogers Broughton, 2nd Lord Fairhaven, 1973.
PD.109–1973, folio 60.

The flowers are identified by inscriptions as lavender (*Lavandula*) and *Rosa centifolia*. The butterfly is a Painted Lady (*Cynthia cardui*) and the birds are identified as a *Pigeon nonnet* (presumably the type now known as a *Pigeon nonain*: a foul-headed nun; but the colouring, white head/black body, is incorrect for a nun which should be black head/ white body, so, despite the inscription it looks as though Robert has painted a clean-legged crested monk pigeon) and a *Chardonneret* (goldfinch). The *Rosa centifolia* or cabbage rose grows to a height and spread of 3 to 5 feet. It is an ancient sterile garden descendant of the Provence Rose (*Rosa gallica*). Its deeply scented blooms appear in June and July.

The birds and butterfly are drawn with the same meticulous attention to detail as the flowers, reminding us that Robert was Louis XIV's Painter in Miniature. The relative proportions of flowers to birds are entirely exaggerated, but, despite the naïvety of the resulting images, the drawing as a whole has great charm and the arrangement on the page shows considerable artistic judgement. On other folios the flowers are accompanied by creatures as diverse as a leopard and a crayfish.

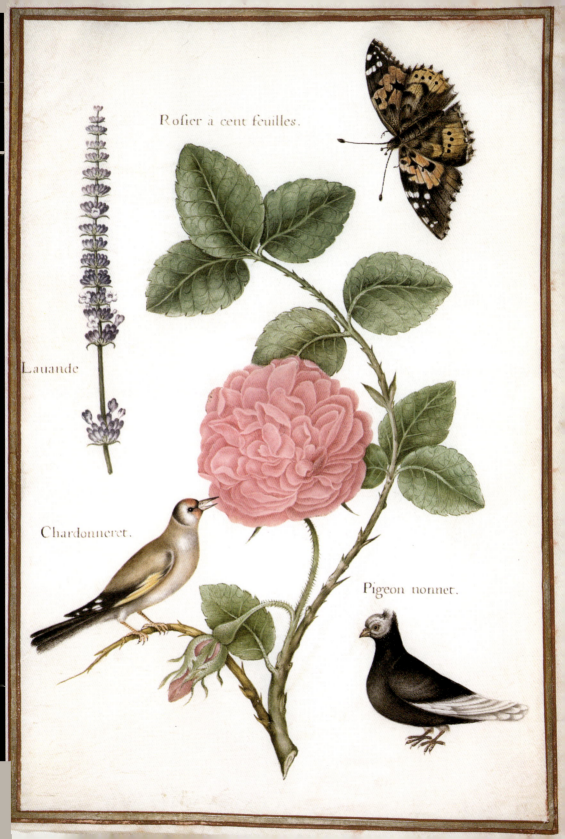

Rofier à cent feuilles.

Lauande

Chardonneret.

Pigeon nonnet.

FRENCH SCHOOL

Seventeenth century

—

PASQUE FLOWER AND COWSLIP WITH A BUTTERFLY

Body colour and watercolour on prepared vellum, framed
by a border of gold and reddish brown paint. 245 × 173 mm.
From an album of 44 drawings on vellum, tipped onto grey paper,
bound in red leather. Bequeathed by Major the Hon. Henry
Rogers Broughton, 2nd Lord Fairhaven, 1973.
PD.126–1973, folio 23.

The flowers' names have been inscribed by a later hand: *Anemone pulsatilla* (pasque flower) and *Primula veris* (cowslip); the butterfly is rather stylised which makes a certain identification difficult, but it may be intended for a cabbage white.

The tradition established in the sixteenth century for this type of florilegium by Le Moyne de Morgues and du Pinet is continued here. The attention to detail is considerable but the handling is not quite so delicate, nor is there quite the same botanical accuracy. Where the artist of this album scores is in the charm of his compositions.

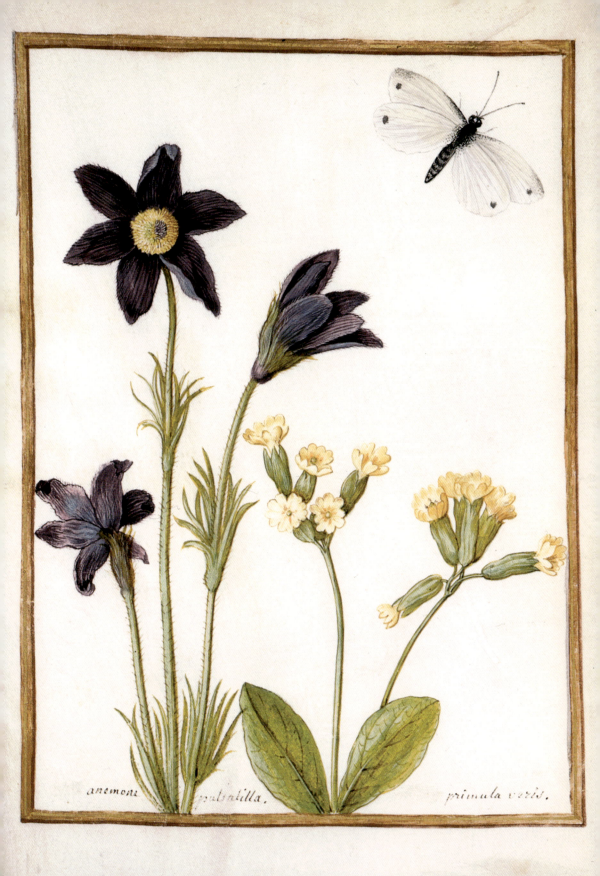

anemone pulsatilla. primula veris.

II

FRENCH SCHOOL

Seventeenth century

—

BLUEBELL AND A DRAGONFLY

Bodycolour and watercolour over traces of graphite on prepared
vellum, framed by a border of gold and reddish brown paint. 243 × 180 mm.
From an album of 44 drawings on vellum. Bequeathed by Major the Hon.
Henry Rogers Broughton, 2nd Lord Fairhaven, 1973.
PD.126–1973, folio 36.

Identified below by an inscription in a later hand as *la jacinthe* (hyacinth), the plant is in fact a bluebell (*Endymion non-scriptus*). Curiously the English bluebell is known in Scotland as a wild hyacinth. The caterpillar climbing the stem of the largest bluebell looks like that of the Camberwell Beauty (*Nymphalis antiopa*).

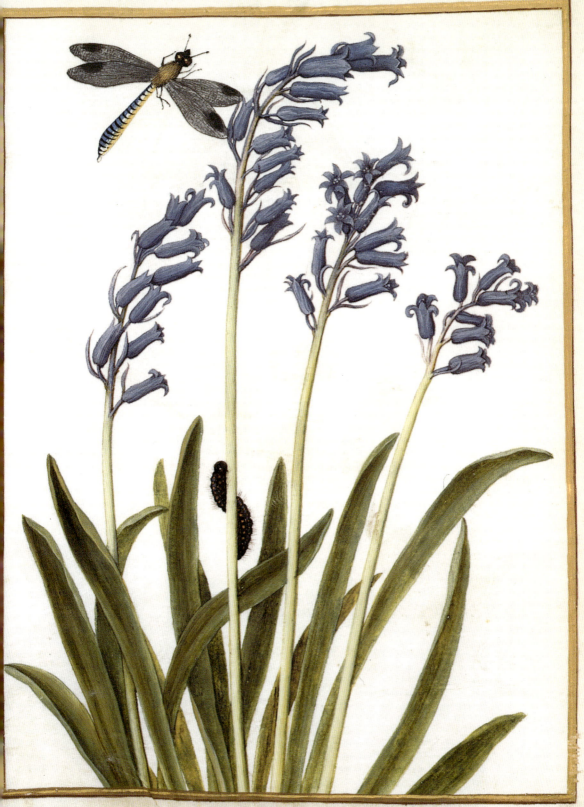

la jacinthe .

MARIA SIBYLLA MERIAN

Frankfurt 1647–1717 Amsterdam

—

SISYRINCHIUM WITH TWO BUTTERFLIES

Bodycolour and watercolour on prepared vellum 372 × 263 mm.
Inscribed in ink, verso, by the artist: '1 caapse blom'. Given by A. F. Griffith,
through the National Art-Collections Fund, 1925. **No.1146 B.**

Daughter of the Swiss engraver, Matthaus Marian (1593–1650); in 1651 her
mother married the German flower painter, Jacob Marrell (1614–81), and it
was from him that Maria Sibylla received her first training. In 1668 Merian
married one of her step-father's pupils, Johann Graff (1637–1701). She worked
in both oils and watercolours, painting flowers, fruit and birds, but her prime
interest was entomology. In 1679 she published the first of three volumes on
European insects, *The wonderful transformation of caterpillars*, illustrated with
her own engravings, hand-coloured with the help of her elder daughter,
Dorothea. She separated from her husband in 1685 and, with her mother and
two daughters, joined a Dutch Labadist convent in West Frisia. In 1691 she
settled in Amsterdam. She visited Surinam (that part of South America later
known as the Dutch, French and British Guianas) in 1699 with Dorothea and
spent two years collecting specimens and drawing insects and plant life; this
resulted in another book, published in 1705, *Metamorphosis insectorum surina-*
mensium. She returned to Holland, where she died.

Women have had considerable *réclame* as flower painters since Christine
de Pisan referred to one called Anastaise *c.*1405. Before Merian the principal
exponent was Clara Peeters (c.1589–after 1657).

The *Sisyrinchium* (sometimes called 'blue-eyed grass') is a native of both
North and South America. This specimen appears to be a *Sisyrinchium bermudi-*
ana from the Eastern United States. It is an annual or perennial herb belong-
ing to the family *Iridaceae*. Characteristically Merian has included details of
botanical interest, such as the bulb and roots. The butterfly, a *Saturnia pavonia*
depicted on the left with wings closed, above, with wings open, shows to
splendid effect Merian's interest in insects.

This drawing previously belonged to Lord Bute, and was bought from his
sale in 1794 by the well-known collector, William Esdaile, whose initials can
be seen in the bottom right hand corner.

PIETER WITHOOS

Amersfoort 1654–1693 Amsterdam

—

ROSE OF PROVENCE

*Point of the brush, bodycolour, watercolour and gum arabic on
prepared vellum. 241 × 194 mm. Inscribed in graphite, verso of old mount:
'Rose de Provins'. From an album of 55 drawings, bound in red covers with the
inscription Fleurs upon it. Bequeathed by Major the Hon. Henry Rogers
Broughton, 2nd Lord Fairhaven, 1973. PD.101–1973 f.3.*

Pieter Withoos was the son and pupil of Matthias Withoos (1621–1703), the
principal follower of Otto Marseus van Schriek (1619/20–1678). Withoos and
his sister, Alida (1659/60–1715), several of whose drawings are also in the
Fitzwilliam's collections, are the best known of Matthias' children, four of
whom followed the family profession of flower painting; the eldest, Jan
(1648–85), was also an accomplished landscape painter. Pieter made a series
of studies of fritillaries in the garden of Louis de Malle at Haarlem and a set of
insect studies.

All fifty-five drawings have inscriptions in French (some are also in Latin)
on the *verso* of the mounts, which suggests they were at one time in a French
collection. The attribution to Withoos depends upon a drawing of an aloe,
(folio 14), which is signed: 'pwithoos: fe', which is clearly by the same hand as
the others. All of them are painted in the same manner and each is of
uniformly high quality.

The Rose of Provence (*Rosa gallica versicolor*) is also sometimes called the
'Rosa Mundi'. This species is the principal wild parent of the old shrub roses.
It is found in South Europe and West Asia and grows to a height and width of
three feet. *Versicolor* is a semi-double sport of *Rosa officianalis*, the red rose of
Lancaster. It is the showiest of all the striped roses, an aspect which clearly
appealed to Withoos. His subtle use of gum Arabic gives a particular brilliance
to the texture of the leaves and the petals and stamens of the flower.

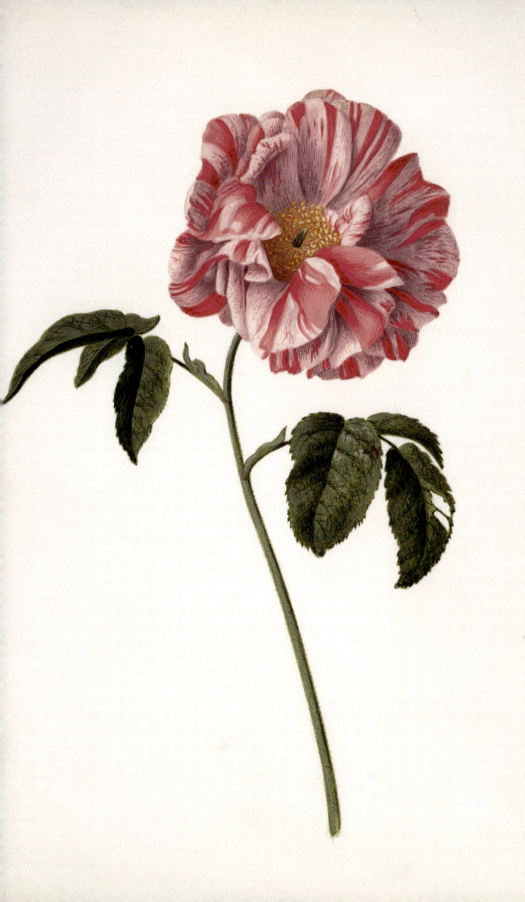

PIETER WITHOOS

Amersfoort 1654–1693 Amsterdam

—

DIGITALIS PURPUREA

Point of the brush, bodycolour, watercolour and gum
arabic over traces of graphite on prepared vellum. 245 × 197 mm.
Inscribed in graphite on verso of old mount: 'Digitale pourpre / Digitalis
purpurea'. From an album of 55 drawings bound in red covers with
the inscription Fleurs upon it. Bequeathed by Major the Hon.
Henry Rogers Broughton, 2nd Lord Fairhaven, 1973.
PD.101–1973 f. 50.

The *digitalis purpurea* or common fox-glove is a native to Western Europe, including Great Britain. It grows up to a height of three to five feet. The spikes of purple, red or maroon spotted flowers are produced from June to July. Withoos has succeeded brilliantly in conveying the tubular effect of the blooms; the heaviness of the unopened ones at the top of the spike contrasts with the flatter florets of those which have opened. Although a common flower, drawings of fox-gloves are not very common at this period.

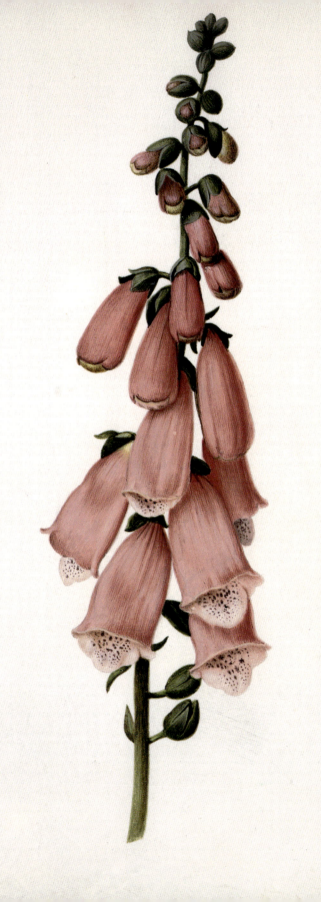

CLAUDE AUBRIET

Châlons-sur-Marne 1665–1742 Paris

—

MIRABILIS DICHOTOMA L.

Traces of stylus underdrawing, bodycolour, watercolour, heightened
with white on prepared vellum, bordered on all sides in gold. 457 × 308 mm.
Inscribed in gold paint, lower right: 'Jalapa officinarum fructu / rugoso. I.r.h.130',
and signed in brown ink, lower right, below the gold border: 'Aubriet p.'.
Bequeathed by Major the Hon. Henry Rogers Broughton,
2nd Lord Fairhaven, 1973. **PD.166–1973.**

Aubriet was born at Châlons-sur-Marne; he moved to Paris where he worked with Jean Joubert (active c.1688–1706) in the production of the *Vélins du roi*. Later he made the engravings for Tournefort's *Elements de botanique* (1694) of which the standard Latin version, *Institutiones rei herbariae*, appeared six years later. In 1700–2 Aubriet accompanied Tournefort as draughtsman on a journey to the Aegean and the Black Sea, resulting in the introduction of a number of new plants to Western Europe, including phlox, sweet-peas and varieties of lily. In 1706 he succeeded Jean Jourbet as the official painter at the Jardin du Roi, a post he held until his death. The *Aubrieta* was named after him.

Mirabilis dichotoma L., the Marvel of Peru, is a native of Mexico. It was introduced to Great Britain in 1596 and was long thought to be a source of the purgative called jalap. That is derived, however, from a Mexican twining plant of a different family, *Ipomoea purga*. *Mirabilis* has fragrant flowers which open late in the afternoon and close in the morning. These have caused it to be called sometimes 'the four o'clock flower'. This drawing may have been intended for a *de-luxe* edition of Tournefort's *Institutiones rei herbariae* and the inscription on it refers to that book, but it was not used for the relevant plate in the published volume.

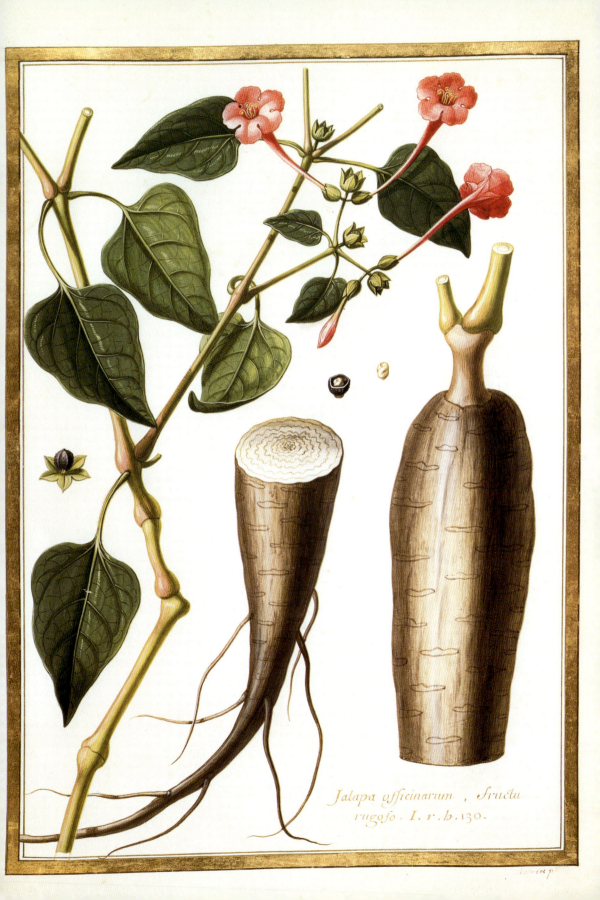

Jalapa officinarum , fructu
rugoso. I. r. h. 130.

HERMAN HENSTENBURGH

Hoorn 1667–1726 Hoorn

•

A GARLAND OF MIXED FLOWERS
ATTACHED TO A WALL

Bodycolour, watercolour, over traces of graphite,
heightened with white on vellum. 403 × 313 mm. Signed,
lower left: 'Herman Henstenburg: fec'. Bequeathed by Major the
Hon. Henry Rogers Broughton, 2nd Lord Fairhaven, 1973.
PD.646–1973

Born at Hoorn, Henstenburgh studied in 1683 with Johannes Bronkhorst (1648–1726/7), who specialised in fine drawings of flowers and insects on vellum. Like that of his master, Henstenburgh's initial training was as a pastry-cook. In addition to flower pieces he also drew landscapes, birds, game and still lifes. He was much admired in his lifetime.

Within the garland, which is attached to the wall by a nail, are the following flowers: holly, double narcissus, auricula, campanula, broken tulip, opium poppies, clematis, hollyhock, mallow, roses, striped cranesbill and groundsel. The composition is enlivened by a judicious scattering of ants and snails and in the foreground is a small tortoiseshell butterfly (*Aglais urticae*).

This is a fine example of a highly finished composition painted on vellum and intended to be displayed as if it were a painting, like the earlier example by Marrell (6). The more sophisticated arrangement of flowers, clearly in the Dutch tradition of Jan Davidsz. de Heem (1606–83/4), is characteristic of Henstenburgh and by the time he was painting half the art of flower painting lay in the arrangement of the flowers. Here Henstenburgh has been particularly successful in expressing baroque profusion, giving a spectacular swagger to the tulip leaf which unfolds from beneath the yellow rose. The combination of flowers which are not necessarily in season together is found quite regularly in finished paintings of the Dutch school. It is interesting to note in the lower foreground that the artist has used his fingers to manipulate the pigment, thereby leaving traces of his fingerprints.

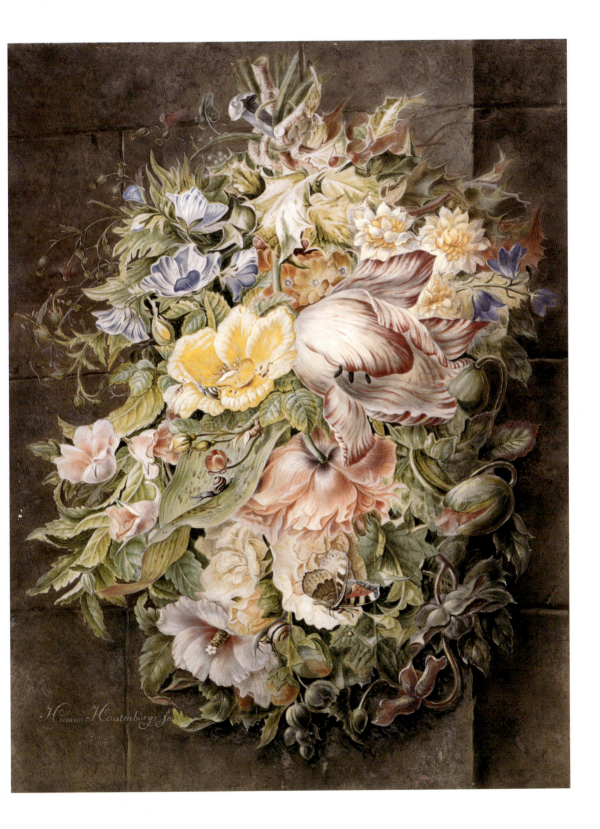

PIETER SNYERS

Antwerp 1681–1752 Antwerp

-

THISTLES

Point of the brush, watercolour, over traces of graphite,
the outer edges all restored. 385 × 223 mm. Signed with initials, lower
right, and dated: 'PS 1735(?)'. Bequeathed by Major the Hon. Henry
Rogers Broughton, 2nd Lord Fairhaven, 1973.

PD.925–1973.

In 1694 Pieter Snyers was a pupil of Alexander van Bredael (1663–1720) in Antwerp. He became a member of the Guild by the mid 1690s, and was made a Master in Brussels in 1705 and in Antwerp in 1708. In 1726 he married. He is thought to have travelled to England where he painted a number of portraits, although he is best known for his landscapes and still lifes. He became Director of the Royal Academy at Antwerp in 1741.

Onopordum acanthium (Scotch thistle) and *Silybum Marianum* (Our Lady's milk-thistle) are shown with a Red Admiral butterfly (*Vanessa atalanta*) and a dragonfly. Snyers' attention to botanical detail is secondary to his placing of the plants in a landscape to give an 'artistic' integrity to his composition. Several flower painters in the late seventeenth and early eighteenth century extended this habit to their flower drawings as well as their paintings in oil, notably Aert Schoumann (1710–1792).

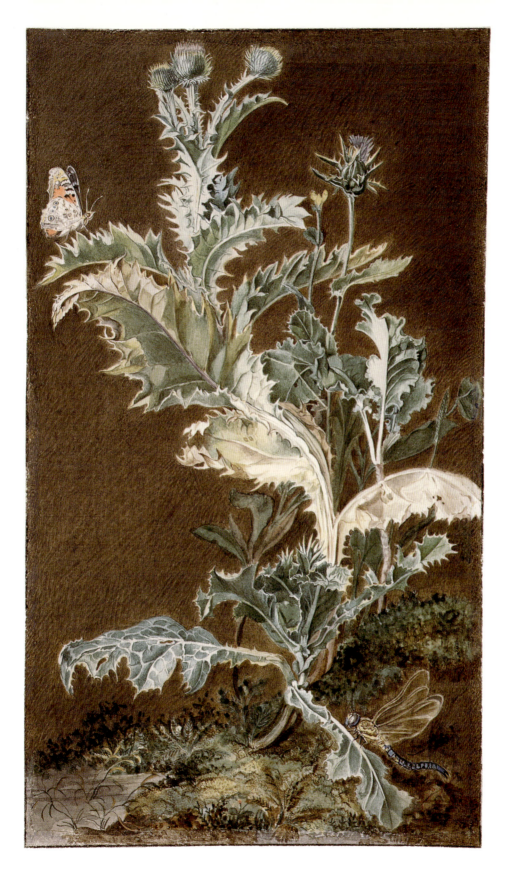

MICHIEL VAN HUYSUM

Amsterdam 1704–c.1760 Amsterdam

•

MIXED FLOWERS IN A CHINESE VASE

Watercolour and gum arabic over graphite.
318 × 191 mm. Signed, in graphite, lower left: 'M v Huysum'.
Bequeathed by Major the Hon. Henry Rogers Broughton,
2nd Lord Fairhaven, 1973. **PD.689–1973.**

Michiel van Huysum was the son of Justus van Huysum (1659–1716) by his second marriage. He is thought to have been taught by his half-brother, Jan van Huysum (1682–1749), from whom he received his patrimony when he came of age, even though the latter is usually credited with only one pupil (Margaretha Haverman [1720–95]). Michiel is last mentioned in 1760, when he made his will. Only five paintings are recorded by him in old catalogues (the Fitzwilliam owns two) but his drawings are more numerous.

In a Chinese vase of K'ang-hsi period (1662–1722), decorated in underglaze blue and celadon, are yellow roses (clearly a type of *centifolia*), Scotch thistle (*Onopordum acanthium*), love-in-a-mist (*Nigella damascena*), crane's-bill (*Geranium renardii* [?]), paeony (*Paeonia officionalis* [?]), ranunculus (*Ranunculus calandrinioides* [?]) and marigold (*Tagetes patula*).

Chinese pots were luxury items and often appear in still-lifes as a symbol of rarity and curiosity. Michiel van Huysum's elder brother, Jan, is probably the most famous of all Dutch flower painters. His oils show a botanical exactness which is quite exceptional, but his drawings (of which there are several examples in the Fitzwilliam) are more generic and seem to have been done to work out the disposition of his compositions. Michiel's drawings in contrast are finished works, which can be seen as alternatives to his oils.

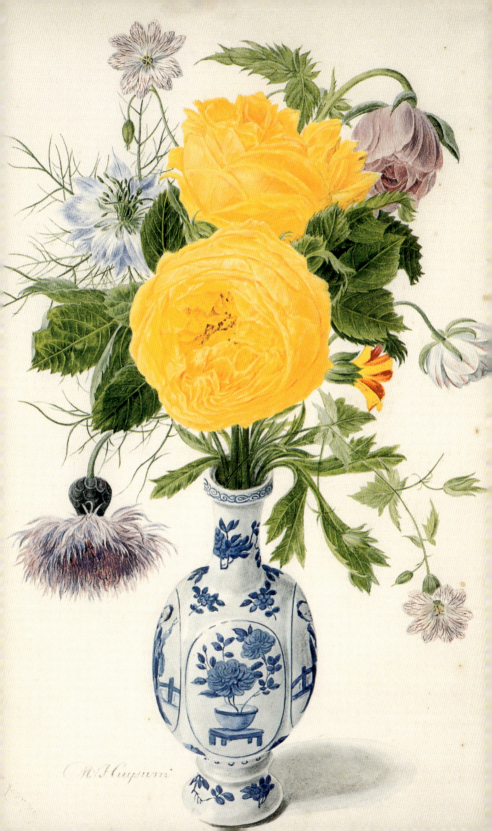

BARBARA REGINA DIETZSCH

Nuremberg 1706–1783 Nuremberg

—

IRIS GERMANICA

*Bodycolour and watercolour with gum arabic on prepared dark
brown ground on vellum, framed by a border of gold. 285 × 204 mm.
Signed, lower right, in white: 'B.R.Diezshin'. Bequeathed by Major the Hon.
Henry Rogers Broughton, 2nd Lord Fairhaven, 1973.* **PD.328–1973.**

Barbara Regina Dietzsch was the elder daughter of Johann Israel Dietzsch
(1681–1754), seven of whose children were to become artists. She may have
worked at the Court of Frederick V in Copenhagen. She made three drawings
specifically for engraving for G.W. Knorr's *Deliciae naturae selectae*, and many of
her drawings were used by Nuremberg engravers as the basis of prints. Some
of the more than one hundred gouache paintings of birds, insects and
flowers, listed in the Grüner residence at Nuremberg are by Barbara Regina,
but the bulk of them are by other members of the Dietzsch family. Nuremberg
was, after London, the most important centre of botanical art in the mid eight-
eenth century, thanks largely to the patronage and enthusiasm of Dr
Christoph Jakob Trew (1695–1760), a wealthy physician, keenly interested in
botany and bibliography.

The blue iris (*Iris germanica*) is native to Southern Europe; in Britain its
common name is the 'London flag'. On the sickle-shaped leaves are a red-
backed beetle and a caterpillar, which may be that of the Marbled Fritillary
(*Brenthis daphne*) or of the Knapweed Fritillary (*Melitaea phoebe*). Characteristic
of the Nuremberg School and of the Dietzsch family in particular is the use of
a dark ground, which acts as a foil to the brilliance of the colours of the flower,
setting it into strong relief. This dramatic contrast emphasises the sharp,
hard finish for which Barbara Regina was famous. She has signed this draw-
ing with the female ending 'in' on her surname, the conventional manner
of the day in Nuremberg. Dr Heidrun Ludwig, whose dissertation on the
Nuremberg School *Nürnberger natürgeschichtliche Malerei im 17 und 18 Jahrhundert*,
Berlin 1993, has done much to elucidate correct attributions, suggests that
this drawing was done early in Barbara Regina's career.

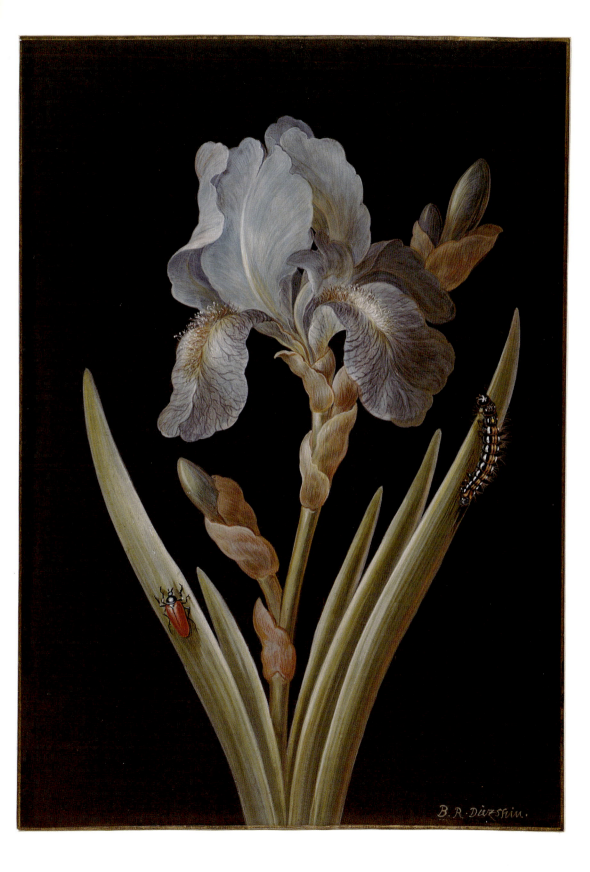

B. R. Dietzsch.

MARGARETA BARBARA DIETZSCH

Nuremberg 1726–1795 Nuremberg

·

TARAXACUM OFFICIONALE

*Watercolour, bodycolour and gum arabic on prepared light
brown ground on vellum. 280 × 198 mm. Bequeathed by Major
the Hon. Henry Rogers Broughton, 2nd Lord Fairhaven, 1973.*

PD.380–1973.

Margareta Barbara Dietzsch was the younger sister of Barbara Regina Dietzsch. Previously thought to have been born in 1716, Dr Heidrun Ludwig has ascertained that her date of birth was in fact 1726. Much of her work was directly inspired by that of her sister and there is still confusion between their work and that of their brother, Johann Christoph Dietzsch (1710–69).

Dandelions *(Taraxacum officionale)* are shown as seed heads with a caterpillar crawling up one stem, a garden tiger moth (?) balanced on a leaf and a blue ichneumon wasp in the top left corner. Whilst the dandelion can become a troublesome weed it produces leaves which, when blanched, can be used in salad.

To paint the seed head of a dandelion with quite such phenomenal attention to detail was a genuine challenge to botanical artists and accounts for the comparative frequency with which the plant appears. The use of a dark ground is almost essential to enable such subtlety to be appreciated. The drawing is based on a painting by Barbara Regina Dietzsch now in Berlin and at least three other drawings of dandelions by Margareta Barbara are known.

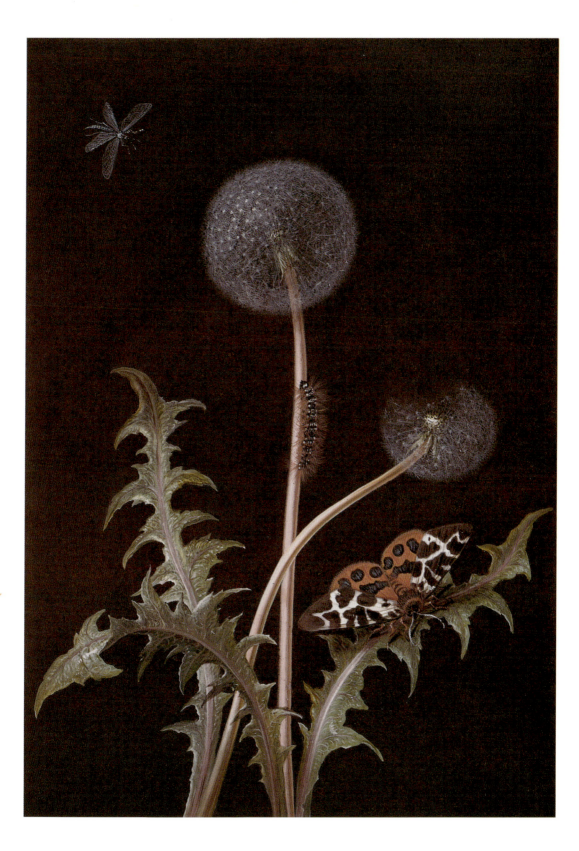

GEORG DIONYSIUS EHRET

Heidelberg 1708–1770 London

—

GENTIANA ACAULIS

Point of the brush, watercolour and bodycolour with gum arabic,
over traces of graphite on prepared vellum. 238 × 165 mm. Numbered in ink,
upper right : '10'; Signed and dated in ink, lower right: 'G.D.Ehret. pinxit/1765';
inscribed in ink, below: 'GENTIANA corolla quimquefida/campanulata, caulem
excedente. Linn.' From an album bound in red morocco tooled in gilt, containing 21
drawings by Ehret, dated between 1764/67, and three drawings by another hand.
The book inscribed on the fly-leaf: 'Mary Ann Barlow/22 pieces in/this book'.
One drawing by Ehret of a geranium (folio 18) missing. Bequeathed by Major
the Hon. Henry Rogers Broughton, 2nd Lord Fairhaven, 1973.
PD.113–1973, folio 10.

The son of a gardener, Ehret's first training was for the Margrave of Baden-Durlach at Karlsruhe. In 1728 he was employed as a draughtsman at Regensburg. In 1731–32 Ehret met Dr Christoph Jakob Trew (1695–1769), later Director of the Imperial German Academy of Naturalists, and the author of several books, many illustrated by Ehret. In 1735 Ehret visited England, where he met Sir Hans Sloane (1660–1753) then President of the Royal Society and Philip Miller (1691–1771), foreman of the Chelsea Garden, whose sister-in-law, Susanna Kennet, he married in 1738. In 1736 Ehret met Charles Linnaeus (1707–78) in Holland and was commissioned to illustrate the *Hortus Cliffortianus*. Ehret returned to England in 1736 and lived there until his death. He became a fellow of the Royal Society in 1757.

The trumpet gentian (*Gentiana acaulis*) is native to Europe. It is distinguished by the extreme brilliance of its colour, an aspect of the plant which Ehret has realised to spectacular effect. The Latin inscription below the plant refers to the description of it by Charles Linnaeus, the great Swedish botanist who introduced the modern system of classifying plants.

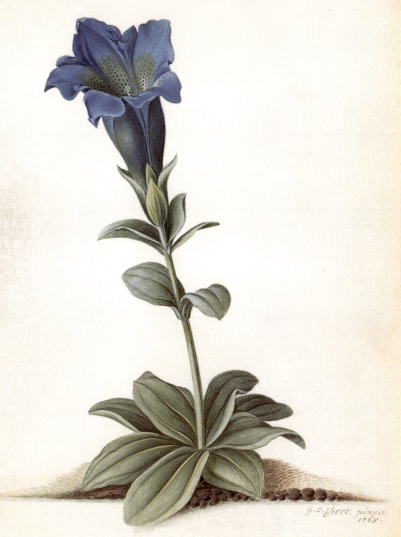

g. d. Ehret. pinxit.
1768.

GENTIANA *corolla quinquefida*
campanulata, caulem excedente. Linn.

GEORG DIONYSIUS EHRET

Heidelberg 1708–1770 London

·

A ROSE, SEEN FROM BEHIND, WITH TWO RANUNCULUS

*Point of the brush, watercolour and body colour with gum
arabic over traces of graphite on prepared vellum. 255 × 177 mm.
Numbered in ink, upper right: '14'; signed and dated in ink, lower right:
'G.D.Ehret. pinxit/1767'; inscribed in graphite, below right: 'Musca meridiana'.
From an album bound in red morocco and tooled in gold containing 21 drawings
by Ehret and 3 drawings by another hand. Bequeathed by Major the Hon.
Henry Rogers Broughton, 2nd Lord Fairhaven, 1973.*
PD.113–1973, folio 14.

The rose is identified as a *Musca meridiana*, which appears to be a variety of the damask rose from West Asia. The ranunculus look like the garden form, *Speciosus plenus* of the *Ranunculus bulbosus*, native to Europe, Asia and North Africa. Ehret was always a master of composition as the intertwining of the stems of the three plants here shows. The fly is drawn with accuracy akin to that of the flowers and it is interesting to note the stamens on the rose head which has lost all its petals towards the top of the composition. Ehret had many followers and pupils and Mary Ann Barlow, the owner of the album from which this drawing comes, may have been one of them. Apart from Sir Hans Sloane, his fashionable patrons in London included Dr Meade, the Royal Physician, and Margaret, Duchess of Portland, whose collection of flower drawings, known as the Portland Museum, was sold at auction in 1786.

G. D. Ehret. pinxit
1767

GEORG DIONYSIUS EHRET

Heidelberg 1708–1770 London

~

OPUNTIA

*Watercolour over graphite. 312 × 226 mm. Inscribed in brown ink,
below left: 'Opuntia / major validissimis / spinis munita. Inst. R.H.'; signed
and dated, lower right: 'G.D.Ehret. /1764'. From an album, bound with seventeenth-
century boards with a new spine of panelled black morocco, tooled in gilt, with the arms
of Antoine Ferrand de Villemilan (1603–89), labelled: 'Drawings of Flowers'; 'Ehret
and Robins', consisting of 109 drawings, of which 108 are by Thomas Robins the
Elder and 1 is by Ehret. Bequeathed by Major the Hon. Henry Rogers Broughton,
2nd Lord Fairhaven, 1973.* **PD.115–1973, folio 38.**

The Opuntia or prickly pear is found all over the Americas and some of the larger species have been introduced into the warmer parts of Europe, where they have become naturalised. Opuntias have jointed stems which may be cylindrical or globular, or flattened into round pads. The number of spines varies, but all species bear tufts of barbed bristles (glochids) on each areole. The glochids can easily pierce the skin and are difficult to remove. Few species survive in Britain unless they are planted out in a large greenhouse. Ehret's understanding of plants was such that he has not needed to draw more than a pad of the opuntia and its flower for any botanist immediately to recognise what it is. It is fascinating to note how broad his handling of watercolour is and how strong his use of colour. The majority of the hundred drawings by Ehret in the Fitzwilliam are in bodycolour on vellum and his approach to that medium is entirely different, more finished, more careful and more elaborate. The immediacy of his approach to defining the salient parts of the plant is much more evident in his work in watercolour. Succulents cannot be represented adequately by herbarium specimens so their illustration is of great importance and in the seventeenth and eighteenth centuries almost essential for their study.

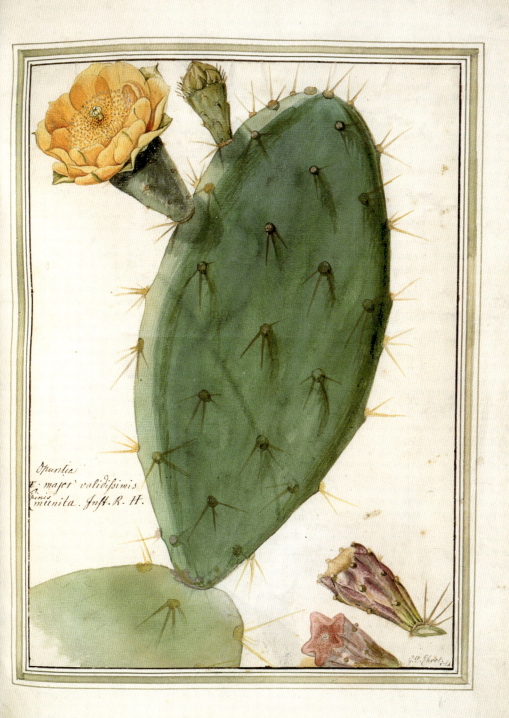

Opuntia
f. major validissimis
Spinis munita. Inst. R. H.

G. D. Ehret.

GEORG DIONYSIUS EHRET

Heidelberg 1708–1770 London

❧

ARUM

Watercolour, body colour and gum arabic, heightened with white over traces of graphite on prepared vellum. 526 × 353 mm approximately (bound in). Inscribed in black ink, below right: 'ARUM Maximum Aegyptiacum / quod vulgo Collocasia. C.B.P.' Signed in black ink, bottom right: 'G.D.Ehret. Pinx.' From an album containing 16 drawings on vellum bound with quarter green morocco, gilt tooled on the spine , marbled boards and marbled end papers. The dated drawings in this album range from 1741 to 1745. Bequeathed by Major the Hon. Henry Rogers Broughton, 2nd Lord Fairhaven, 1973. **PD.116–1973, folio 14.**

The Arum lily (*Zantedeschia Aethiopica*) is a native of South Africa. Ehret's inscription calls it the Egyptian Arum, vulgarly called Colocasia. This is probably a form of *Zadanteschia elliotiana* or *pentlandii*, both of which are yellow and come from the Transvaal. This spectacular drawing uses the limitations of the size of the piece of vellum on which it is drawn to dramatic advantage by leaving no edge unpainted. It was no.18 of a group of 208 drawings commissioned by Dr Richard Mead (1673–1754), physician to King George II. The 'ingenious' Dr Mead has been called the 'most celebrated virtuoso of the age'. He lived in Great Ormond Street, London, where he allowed students access to his library of some 10,000 volumes and to his collection of pictures, statues, coins, objects of virtue, etc. Ehret wrote in his autobiography that he had 'prepared for him, from time to time, paintings of rare plants...the number of them reached at last 200'. He gratefully records that Dr Mead showed these paintings to every one 'in order to bring me on in the world'. Dr Mead paid Ehret one guinea for each of them. The Arum is commonly known as a wake robin, or cuckoo pint. A sketch and a finished painting on paper are recorded by Enid Slatter in her unpublished dissertation on Ehret and Dr Mead in the Botany department of the Natural History Museum, London, and there is an engraving of it by Haid, published in Trew's *Plantae selectae*, Augsburg, 1750–73.

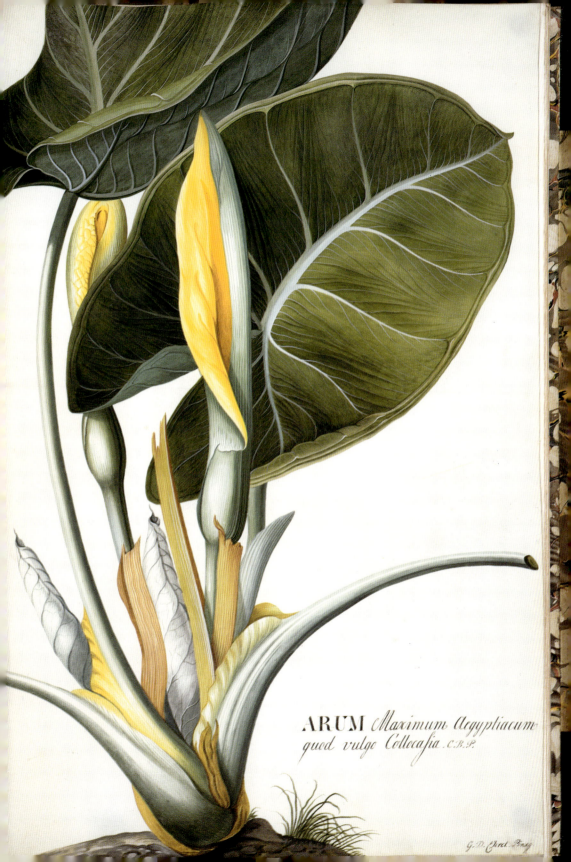

ARUM *Maximum Aegyptiacum*
quod vulgo Collocasia .C.B.P.

G.D. Ehret. Pinx.

GEORG DIONYSIUS EHRET

Heidelberg 1708–1770 London

•

HURA CREPITANS L.

Bodycolour and watercolour with gum arabic over traces of graphite
on prepared vellum. 536 × 373 mm. Inscribed in black ink extensively in Latin,
giving a description of the parts of the flower, and below, its name and place and time of
flowering, with the comment that he, Ehret, had observed it and drawn it in November
1738. From an album containing 26 drawings on vellum, bound in sprinkled calf,
the spine lettered in gilt. The dated drawings in this album range from 1738
to 1766. Bequeathed by Major the Hon. Henry Rogers Broughton,
2nd Lord Fairhaven, 1973. **PD.117–1973, folio 17.**

The Hura crepitans L. is also known as the sandbox tree; it is a native of the West Indies and South America. It has a round hard-shelled fruit about as large as an orange, which when ripe and in a dry atmosphere bursts with a loud noise, throwing the seeds many feet. The abundant milky juice is poisonous. This painting was used by Trew for plates 34 and 35 of his *Plantae selectae*. As the inscription shows, Ehret drew a specimen which had flowered at Chelsea in the Physick Garden in November 1738. 'H.L.' in the inscription refers to the *Hortus Linnaei* (Linnaeus' garden). Of all the drawings by Ehret in the Fitzwilliam this outstanding example shows the strongest influence of Charles Linnaeus, the Swedish botanist and gardener whom Ehret met in Holland in 1736. Reminiscent of Ehret's famous drawing of 1736 (Natural History Museum, London) showing the 'Tabella' of Linnaeus' sexual system of plant classification, the male flower is exhaustively treated in figures *a–i*, and the fruit and seed in figures *t–z*. The drawing was no. 94 in Dr Richard Mead's collection. Enid Slatter (see no.24) records an engraving by Ehret in his *Plantae et papiliones rariores* dated 1745 and two versions on paper, in the Natural History Museum, London, and the Hunt Institute, Pittsburgh.

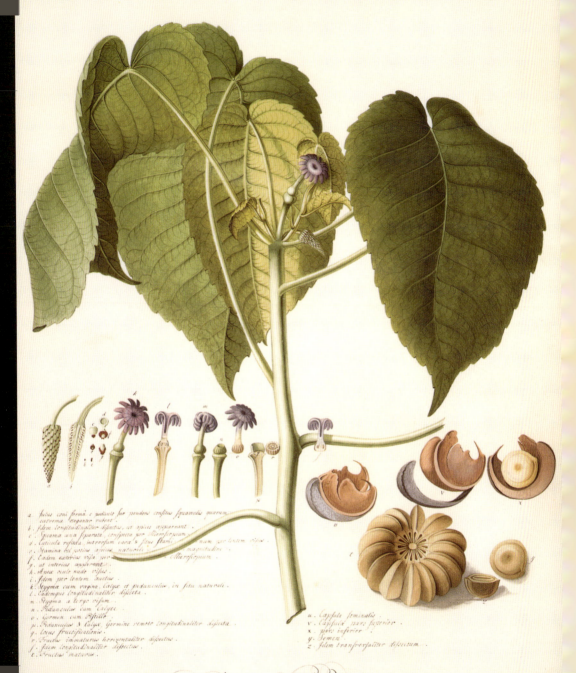

a. *fetus coni formâ e pediculo suo pendens confitus squamulis quarum* *extrema elegante robore*.

b. *idem longitudinaliter difectus, ut spica appareant*.

c. *Squama una feparata, confpecta per Microfcopium*.

d. *Cuticula refiexa, introrfum caca & fine flavedinem per lentem vifa*.

e. *Stamina bel potius amina naturali magnitudine*.

f. *Eadem exterius vifa per Microfcopium*.

g. *at interius appareant*.

h. *Apex oculo nudo vifus*.

i. *idem per lentem auctus*.

k. *Stygma cum vagina, Calyx et pediauntibus in fitu naturali*.

l. *Eademque longitudinaliter difsecta*.

m. *Stygma a tergo vifum*.

n. *Pedunculus cum Calyce*.

o. *Germen cum Piftillo*.

p. *Pedunculus & Calyx, Germine remote longitudinaliter difsecta*.

q. *locus fructificationis*.

r. *fructus immaturus horizontaliter difsectus*.

s. *idem longitudinaliter difsectus*.

t. *fructus maturus*.

u. *Capfula feminalis*.

v. *Capfula pars fuperior*.

x. *pars inferior*.

y. *Semen*.

z. *idem tranfverfaliter difsectus*.

HURA *Americana Abutili folio. H.L.*

floruit in Horto Chelfeyano Menfe Novembri 1758. Georgius Dionyfius Ehret, obferravit et delineavit.

GEORGE DIONYSIUS EHRET

Heidelberg 1708–1770 London

—

MUSA

Watercolour, bodycolour and gum arabic over traces of pencil
on prepared vellum. 373 × 536 mm. Inscribed in black ink, lower centre:
'MUSA: candice maculato fructu recto, rotundo, treviore, odorato, Sloan.Cat.';
signed in black ink, lower right: 'G. D. Ehret.P.' From an album containing 26 drawings
on vellum (see 24). Bequeathed by Major the Hon. Henry Rogers Broughton,
2nd Lord Fairhaven, 1973. **PD.117–1973, folio 19.**

The drawing shows the flowers of the banana tree (*Musa sapientum*). It was no.
143 in Dr Richard Mead's collection. Another version in watercolour on paper
is in a private collection in Surrey and the drawing was engraved by Trew in
1752. Dr Mead owned another drawing on vellum of the banana tree, which is
now in the collection of the Earl of Derby, Knowsely Hall, Merseyside, which
was also engraved by Trew in 1752. Ehret's sense of the dramatic is exem-
plified in this drawing with its vivid colour and startling sense of design. All
Ehret's botanical drawings convey a real sense of his love of plants and of his
intention to depict them in as accurate and sympathetic manner as possible.
Although Redouté's current reputation may be higher with the general public,
close consideration of Ehret's work shows him to be no less gifted both as a
botanist and as a draughtsman.

Further reading Gerta Calmann, *Ehret, flower painter extraordinary*, London, 1977.

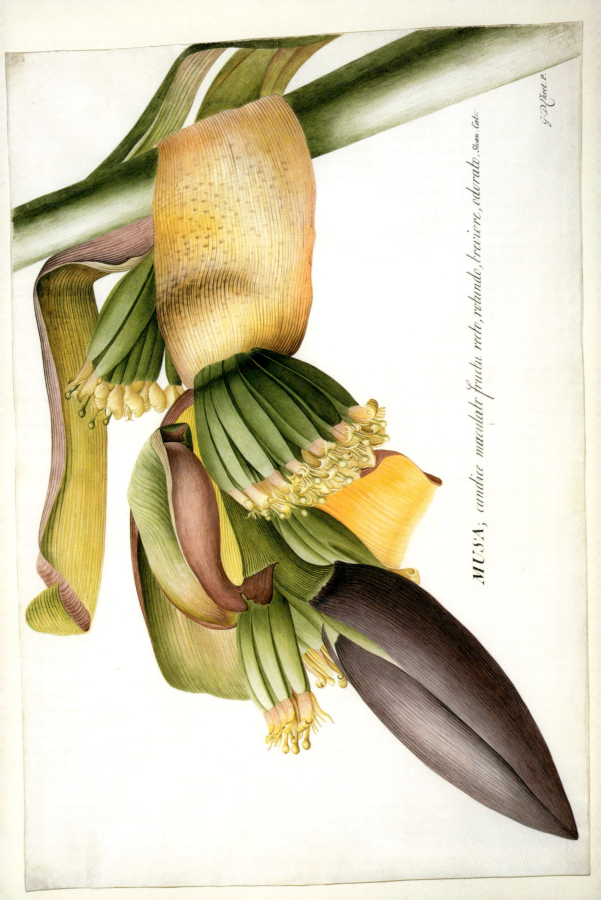

MUSA; caudice maculato fructu recto, rotundo, breviore, odorato. Stam. Gato.

G. D. Ehret. P.

THOMAS ROBINS THE ELDER

Charlton Kings 1716–1770 Bath

—

A BUNCH OF ORNAMENTAL
FLOWERS TIED WITH A RIBBON,
SURROUNDED BY MOTHS AND BUTTERFLIES

*Watercolour and bodycolour with gum arabic over graphite on paper.
466 × 357 mm. Signed and dated in brown ink, bottom left: 'T:Robins
pinxt 1769'. Bequeathed by Major the Hon. Henry Rogers Broughton,
2nd Lord Fairhaven, 1973.* PD.912–1973.

There are two artists of this name, father and son. Thomas Robins the Elder
was a topographical painter and draughtsman, who used flowers as a decora-
tive feature in the borders of his paintings of country houses. Thomas Robins
the Younger (Bath 1748–1806 Bath) is known for his botanical drawings. Until
recently their styles were not differentiated and even now there is considerable
room for doubt, as it is likely that the father taught the son. An album in the
Fitzwilliam of 108 drawings (see 28, 29), clearly by the same hand, contains
one drawing dated 1762, which implies that the group is by Robins the Elder.
Definite drawings by Robins the Younger, dated after his father's death, show
similarity in both composition and handling, but are not always so delicate.

A drawing clearly intended for display, the flowers include *Cyclamen
sp.*(Cyclamen), *Corydalis sp.* (Corydalis), *Dianthus barbatus* (sweet William),
Citrus limon (lemon blossom) *Tulipa sp.* (broken tulip [Parrot]), *Delphinium con-
solida ambigua* (double larkspur), *Gypsophila sp.* (Gypsophila) and *Gentiana sp.*
(trumpet gentian). The moths and butterflies include *Vanessa atalanta* (Red
Admiral), *Anthocharis cardamines* (Orange Tip), *Ladoga camilla* (White Admiral),
Apatura iris (Purple Emperor, male) *Zygaena sp.* (six-spotted burnett), *Arctia vil-
lica* (Cream Spot Tiger Moth), *Saturnia pavonia* (Emperor moth), *Apatura iris*
(Purple Emperor, female) and *Gonepteryx rhamni* (brimstone). Drawings of
lemon blossom and of Corydalis, identified severally as 'Cirtron (sic) blossom'
and 'Fumaria', appear on pages 32 and 12 of the Robins' album. This may have
been painted for the Duchess of Portland.

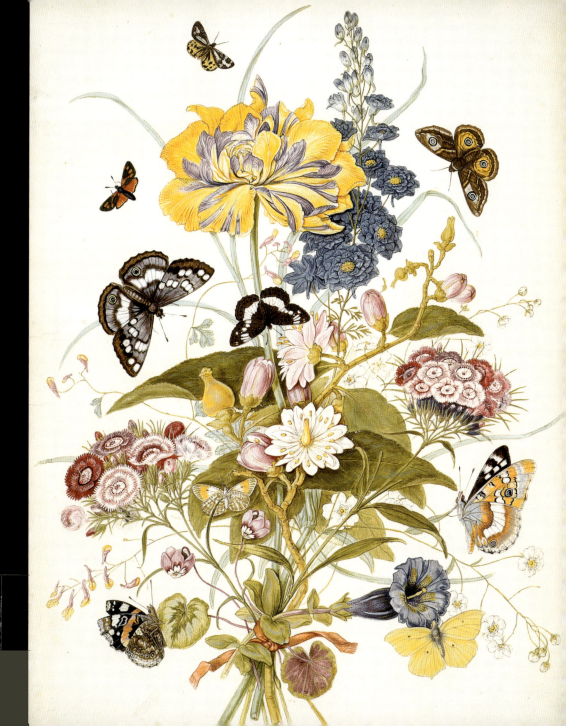

THOMAS ROBINS THE ELDER

Charlton Kings 1716–1770 Bath

•

YUCCA, CAPE MARIGOLD
AND MESEMBRYANTHEMUM

Watercolour and bodycolour over traces of graphite on paper.
255 × 197 mm. Inscribed by the artist in black ink: 'Yucca or Adam's Needle.';
'Cape Marigold.'; 'Misembrianthimum [sic] or Fig Marigold.', this last numbered
in red ink: '3'. From an album, bound with seventeenth-century boards with a new spine
of panelled black morocco, tooled in gilt, with the arms of Antoine Ferrand de Villemilan
(1603–89), labelled: 'Drawings of Flowers'; 'Ehret and Robins', consisting of 109
drawings of which 108 are by Thomas Robins the Elder and 1 is by Ehret.
Bequeathed by Major the Hon. Henry Rogers Broughton, 2nd Lord
Fairhaven, 1973. **PD.115–1973, folio 19.**

As is often his custom in the pages which make up this florilegium, Robins has identified the flowers with their contemporary English names. The *Yucca filamentosa*, commonly called Adam's needle, comes from the South East of the United States. The *Dimorphotheca* or Cape marigold is an African daisy, which, as its common name implies, comes from South Africa. The *Mesembryanthemum* also comes from South Africa. It is clear that all the plants drawn in the Robins' album were done from nature. The placing of the plants on the page is carefully worked out and regularly their stems intertwine or overlap, creating a very pleasing sense of design. The palette used by Robins is often a delicate one, in contrast to the startling colour Ehret used in the one drawing of his included in the album (see 23). The style is remarkably similar to a group of drawings attributed to Ehret in the collection of the Earl of Derby.

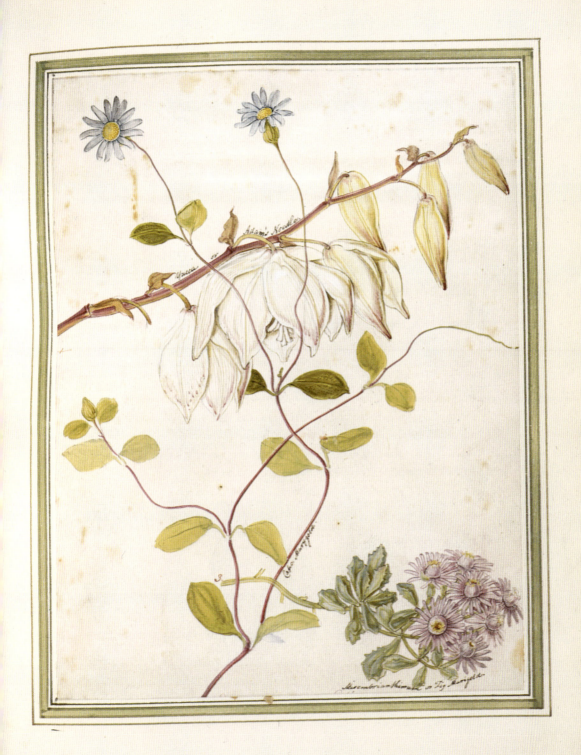

Adam's Needle

Yucca

Chrysanthemum

3

Mesembryanthemum or Fig Marigold.

THOMAS ROBINS THE ELDER

Charlton Kings 1716–1770 Bath

•

AURICULAS IN A FLOWER POT

*Watercolour and bodycolour over graphite. 241 × 184 mm. Inscribed in black
ink, in the artist's hand: 'Roy's Baker'; 'Pitt'. From an album, bound with seventeenth-
century boards with a new spine of panelled black morocco, tooled in gilt, with the arms
of Antoine Ferrand de Villemilan (1603–89), labelled: 'Drawings of Flowers'; 'Ehret
and Robins', consisting of 109 drawings of which 108 are by Thomas Robins the Elder
and 1 is by Ehret. Bequeathed by Major the Hon. Henry Rogers Broughton,
2nd Lord Fairhaven, 1973. **PD.115–1973, folio 70.***

Long cultivated for display, this old garden flower is probably derived from
hybrids between two European alpine species, *Primula auricula* and *Primula
rubra*. This type was referred to as a lace-edged polyanthus. Here the two
different polyanthus are identified by their contemporary names 'Roy's Baker'
and 'Pitt'. Other named examples appear in the Robins' album on page 88,
'Trumpet Arch', 'Cardinal de Fleury' and 'Gloria Mundi'. 'Roy's Baker' has
been identified by Ruth Duthie as 'Vice's Royal Baker', a green-edged auricula
of a type which came to occupy the honoured place it has enjoyed since it first
appeared, probably in the 1760s, when this drawing is likely to have been
made. Separate classes for green-, grey-, and white-edged flowers were formed
by the beginning of the nineteenth century.

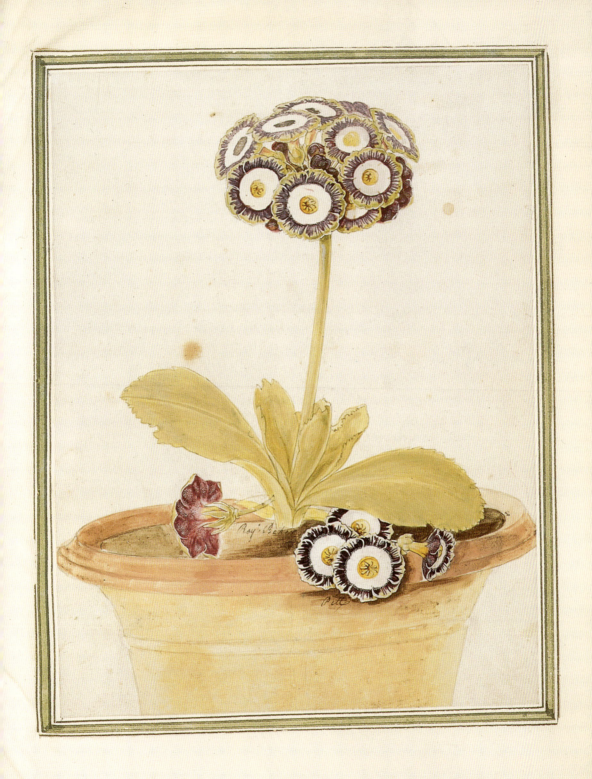

ALEXIS-NICOLAS PERIGNON
THE ELDER

Nancy 1726–1782 Paris

•

ROSE BUSH WITH A BUTTERFLY

*Bodycolour and watercolour on paper, discoloured brown,
laid down on a washed mount. 241 × 186 mm. Inscribed on the mount,
lower left, in brown ink: 'd'après nature par Perignon'. Bequeathed by Major
the Hon. Henry Rogers Broughton, 2nd Lord Fairhaven, 1973.*

PD.861–1973.

Born in Nancy in 1726, Perignon was active not just as a botanical draughts-
man, but also as an architect, lawyer and engraver. As a painter he is better
known for his landscapes than for his still lifes. He began as an architectural
draughtsman and shortly afterwards showed a sensitive ability as a flower
painter. His usual medium is bodycolour (gouache), which he manipulated
with great freshness. He was made a member of the Académie in 1774 and his
work was much sought after by collectors. The Marquise de Pompadour par-
ticularly appreciated him. He made several journeys to Switzerland where he
painted landscape, but he abandoned that for flower painting, a field in which
he had shown so much taste and lightness of touch. He died in Paris.

It is difficult to gauge the scale of the rose bush. It might be a miniature,
or it could be a rather tidy noisette rose. The butterfly is a *Colias myrmidone*
(Danube clouded yellow). The drawing has all the charm and intimacy for
which Perignon was famous. Originally the tonal contrast would have been
different as the background would have been white.

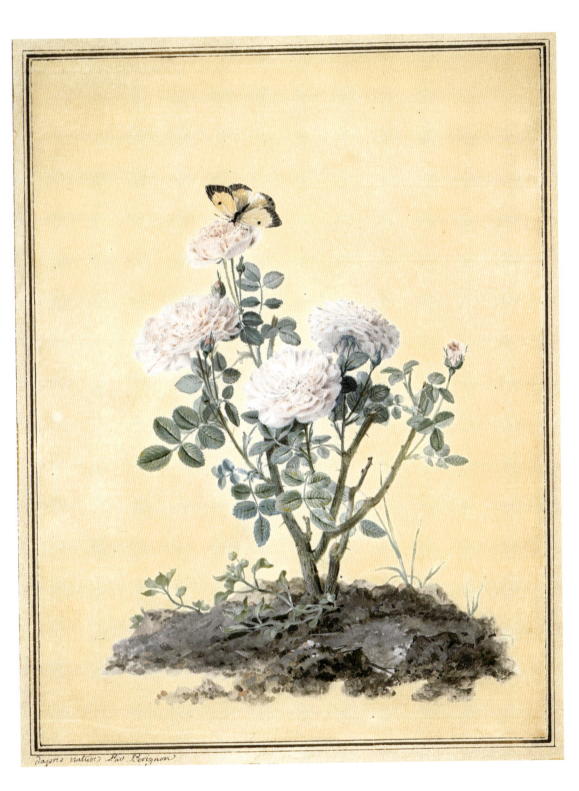

d'après nature Par Perignon

AUGUSTIN HECKEL (OR HECKLE)

Augsburg c.1690–1770 Richmond

—

HORSE CHESTNUT

Watercolour and bodycolour over traces of graphite on paper.
330 × 214 mm. Numbered in brown ink, upper right :'60'; inscribed
and dated in ink, below: 'The Horse Chesnut'; 'May 1748'. From an album
containing 236 drawings and prints by Heckel, of which 181 are flowers, bound
in brown leather and tooled. Inscribed in gilt lettering on red leather, affixed to the
spine: 'Drawings / by / Heckel'. Bequeathed by Major the Hon. Henry Rogers
Broughton, 2nd Lord Fairhaven, 1973. **PD.99–1973, folio 60.**

Augustin Heckel was born in Augsburg, the son of Michael Heckel. He trav-
elled to London via Paris and settled in England. He published two books on
flowers with his own engravings, *The Lady's drawing book* in 1755 and *The florist*
in 1759. He retired to Richmond in Surrey, where he died. A little more can be
gleaned from this album. Primarily a draughtsman of flowers, there are three
colour prints of bouquets of flowers signed in the plate and there is a drawing
of a dog, preparatory to a print signed in the plate with the monogram 'AH'.
An inscription by a previous owner of the album, Margaret Johnstone, dated
June 5 1804, gives additional information: 'A collection of 230 [sic] Drawings
in Natural History &c. in Watercolours very highly finished by Heckel. These
drawings chiefly consist of Plants, Flowers, Birds and a few Landscapes, &
other subjects, all taken from Nature in the greatest preservation imaginable,
the Colouring as fine as when first drawn, and said to have been valued by the
late Mr Langford at £200 and to have been the employment of a great part of
Mr Heckel's life.' The drawings in the album are dated variously between 1746
and 1766.

The *Aesculus hippocastanum* (horse chestnut) is a native of the wild border-
lands between Albania and Greece. One of the most impressive of all large
ornamental trees, it has been long a favourite for avenues or as a village or
commemorative tree. Heckel has drawn the leaf with a spray of blossom
within it, showing clearly the dense terminal panicles characteristic of the
flower, which blooms in May.

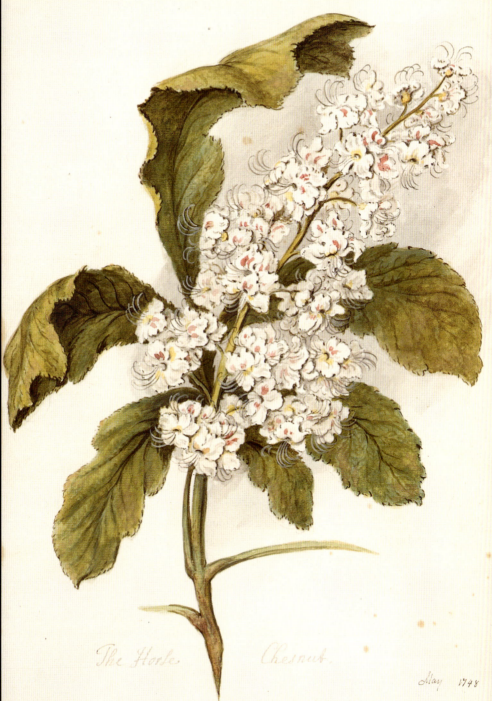

The Horse Chesnut.

May 1748

MARY MOSER

London 1744–1819 London

—

MIXED FLOWERS IN AN URN ORNAMENTED WITH THE ASTROLOGICAL SYMBOL FOR ARIES, ON A STONE LEDGE

Pen and ink, watercolour, bodycolour and gum arabic over traces of graphite on paper with a prepared dark ground, except in those areas where the flowers are light. 620 × 470 mm. Signed in black ink, lower right: 'Mary Moser f.' Bequeathed by Major the Hon. Henry Rogers Broughton, 2nd Lord Fairhaven, 1973. **PD.818–1973.**

Mary Moser was the only daughter of Georg Michael Moser (1706–83), a Swiss portraitist and goldsmith who settled in England and taught drawing after the antique to, amongst others, King George III. She specialised in flower painting and exhibited at the Society of Arts, where she was awarded premiums in 1758 and 1759. Like her father, she was a founder member of the Royal Academy (1768), where she exhibited regularly from 1769–1802, initially flower pieces, but later and more often history paintings. She decorated a room at Frogmore in Windsor Park for Queen Charlotte, which came to be known as 'Miss Moser's room'. Despite an earlier attachment to the Swiss artist Heinrich Füssli (1741–1825), she married Captain Hugh Lloyd in 1797. After her marriage she painted only as an amateur, signing her paintings: 'Mary Lloyd'. After 1802 she stopped exhibiting, apparently because of failing eyesight.

The flowers include *Anemone coronaria* (Anemone de Caen), *Hyacinthus orientalis albulus* (Roman hyacinth), *Calendula officinalis* (?) (pot marigold), *Paeonia lactiflora* (paeony), *Narcissus pseudo Narcissus* (daffodil), *Narcissus jonquilla* (jonquil), *Malus silvestris* (apple blossom), *Tulipa* (tulip), *Citrus aurantium* (?) (Seville orange), *Cydonia oblonga Roseaceae* (quince blossom), *Primula auricula* (Auricula), *Ornithogalum umbellatum* (?) (Star of Bethlehem), *Clematis* (Clematis) and *Prunus persica* (peach blossom). All these flowers are to be found in bloom during the ascendancy of the astrological sign Aries, March – April. This is one of a group of drawings in which other signs of the Zodiac are included in the decoration of the vase. Those for Gemini, Libra, Sagittarius, Capricorn and Pisces are also in the Fitzwilliam. Three of them are dated, Gemini 1765, Capricorn 1766 and Sagittarius 1768. All are of the same size and were presumably once part of twelve highly decorative arrangements of floral seasons.

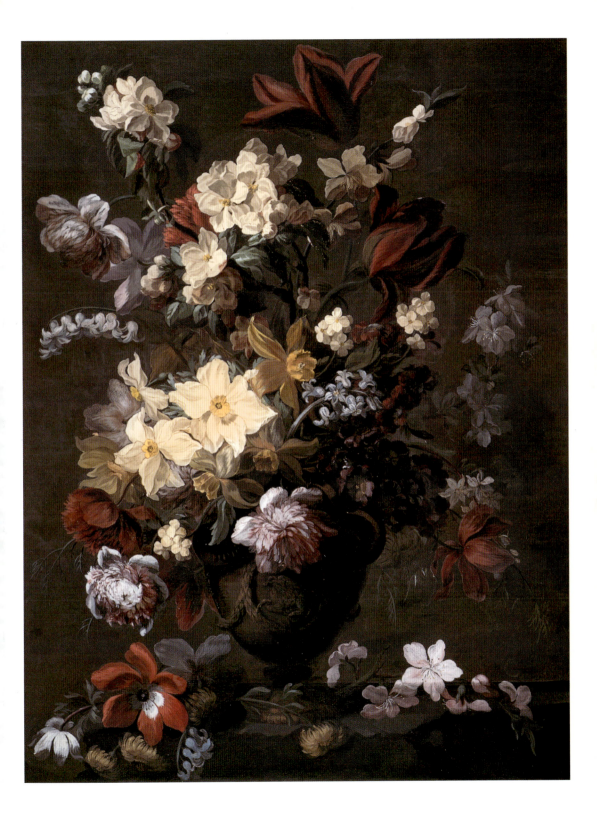

DOROTHÉE-ANNE VALLAYER-COSTER

Paris 1744–1818 Paris

—

STILL LIFE OF MIXED
FLOWERS IN A GLASS ON A LEDGE

Bodycolour and watercolour on paper. Oval, 259 × 206 mm.
Signed in ink with a monogram and dated, lower left: '1788/DAV'
Bequeathed by Major the Hon. Henry Rogers Broughton,
2nd Lord Fairhaven, 1973. **PD.963–1973.**

Anne Vallayer was born in Paris, the daughter of a royal goldsmith, Joseph Vallayer, who worked at the Gobelins factory. She was admitted to the Académie Royale in 1770 and appointed painter to Queen Marie-Antoinette in 1780. She first exhibited at the Salon in 1771. In 1781 she married an *avocat de parlement*, J.-P. Silvestre Coster, but continued throughout her career to exhibit as Anne Vallayer. She found less favour under the Revolution and the Empire, but still exhibited regularly at the Salon until 1817. In addition to flower painting she also painted portraits and genre scenes and was active as a printmaker.

The glass contains roses, broken tulips, lilies-of-the-valley, violas, cross-wort, seed heads of the pulsatilla, scabious and an ox-eye daisy. Although the flowers are clearly identifiable, Mlle Vallayer's technique is primarily painterly and her interest is not specifically botanic. A sensitive artist, she had the misfortune to be described by Diderot as 'one of Chardin's victims'. The reason, if not the justice, for such a comment can be seen in this drawing, with its investigation of variety and richness of surface effect and its use of dry pigment to suggest pastel. Similar simple glass tumblers appear in at least two other paintings by her, one dated 1777, the other 1804.

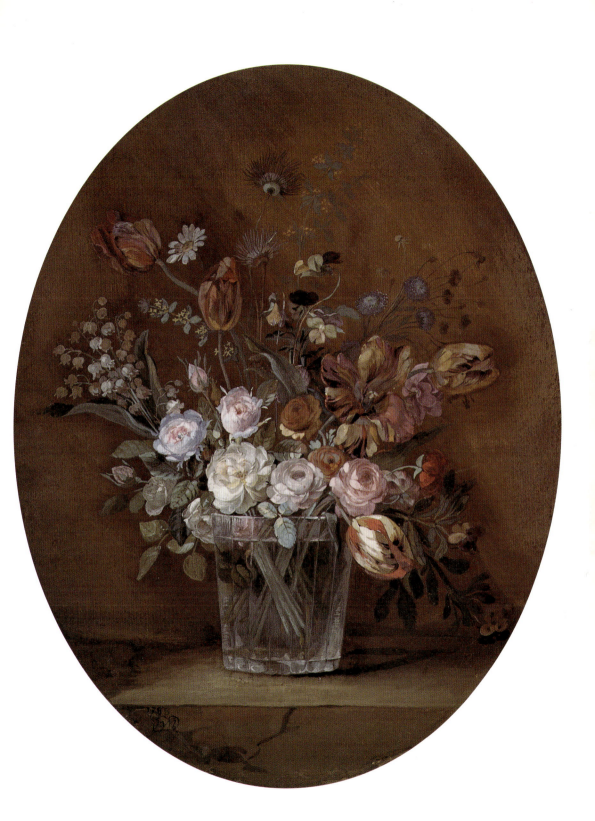

FRIEDRICH KIRSCHNER

Bayreuth 1748–1789 Augsburg

●

WEEDS FROM A GERMAN ROADSIDE

*Bodycolour with gum arabic on vellum prepared with
a dark brown ground, bordered on all sides with a line of black
wash. 361 × 276 mm. Bequeathed by Major the Hon. Henry
Rogers Broughton, 2nd Lord Fairhaven, 1973.*

PD.315–1973.

Previously attributed to Barbara Regina Dietzsch (1706–83) (see 19), Heidrun Ludwig recognised the hand of Friedrich Kirschner, a pupil of G.F. Riedel, in Ludwigsburg. Born in Bayreuth, after his initial training he worked for the porcelain factory in Ludwigsburg before going to Nuremberg and then on to Altdorf where he made paintings for the botanical gardens. He also worked in Augsburg. He was active, too, as an engraver. In addition to botanical drawings Kirschner is known for his studies of fruit and insects and landscape drawings. He died in Augsburg.

The weeds are: *Solanum nigrum*; *Trifolium pratense* (clover); *Calendula arvensis* (marigold); *Anchusa officianalis* and *Plantago media*. The butterfly on the clover is a female *Everes argiades* (Short-tailed blue). Kirschner continues in the tradition of the Dietzsch family, painting on a dark ground so that the colours he uses shine out with greater luminosity. His handling of the medium is exceptionally delicate and is less robust than the Dietzsches. Ten drawings from the Broughton Collection are clearly by the same hand and they may all have been drawn when Kirschner was working at Altdorf. This drawing is unusual in its depiction of plants which are generally considered weeds, strongly suggesting that Kirschner took a walk outside the garden.

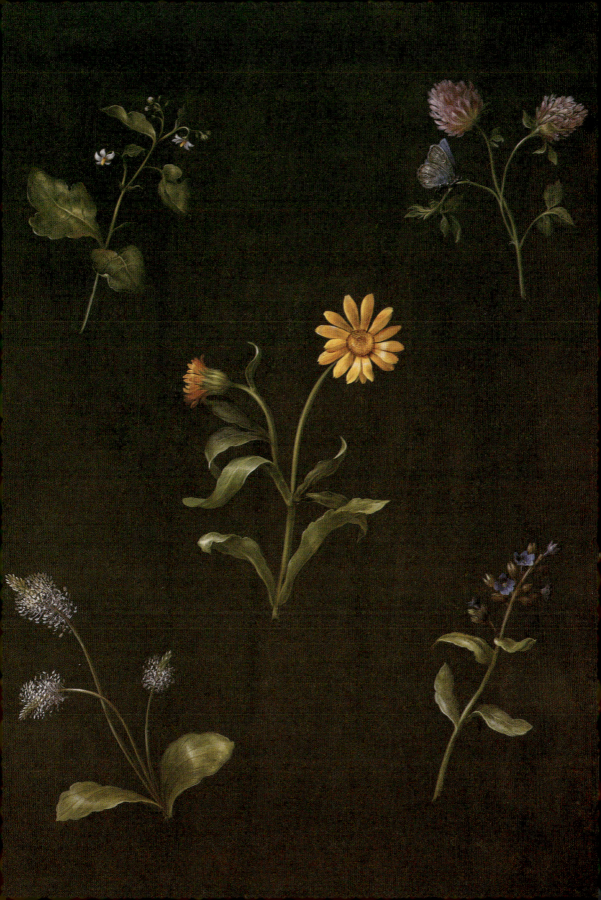

35

ELIZABETH BURGOYNE

Active in London c.1752–1807/9

·

HALIMIUM FORMOSUM

Bodycolour and watercolour over traces of graphite on prepared vellum.
299 × 236 mm. Inscribed in black ink, lower left: 'Cistus Formosa'; signed with
initials and dated in black ink, lower right: 'E.B. 1787'. From an album containing
68 drawings, 22 by Peter Brown (active 1766–91), 2 by Frederick Polydore Nodder
(active 1773–88), 41 by Elizabeth Burgoyne and 2 by Charles Schweychert (active
1815), bound in green morocco, tooled in gold with a silver clasp, bearing the
monogram: 'EB'. Bequeathed by Major the Hon. Henry Rogers Broughton,
2nd Lord Fairhaven, 1973. **PD.108–1973, folio 26.**

Elizabeth Burgoyne may be identified as the Mrs Montagu Burgoyne to whom
William Curtis dedicated the first volume of the *Botanical Magazine* in 1787. Of
her he wrote, she was 'not less esteemed for her social and domestic virtues
than admired for the accuracy with which she draws...the beauties of Flora.'
Apart from the forty-one drawings contained in this album the Fitzwilliam
owns six other drawings by her. Many of these are signed and dated; the dates
range from 1785 to 1809.

Halimium lasianthum formosum (rock rose) is a native of Portugal, related to
the *Cistus* and the *Helianthemum*, which explains Mrs Burgoyne's mistaken
inscription at the bottom of the drawing. The placing of the drawing on the
page shows that the artist was aware of Ehret's example and it is possible that
she was one of his many pupils.

76

Cistus heterosus

E. B. 1787

PETER BROWN

Active in London 1766–1791

—

CLEMATIS SP.

Watercolour and bodycolour over traces of graphite on prepared vellum.
301 × 237 mm. Signed in black ink, lower left: 'P.Brown'. From an album containing
68 drawings, 22 by Peter Brown, 2 by Frederick Polydore Nodder (active 1773–88),
41 by Elizabeth Burgoyne (active c.1752–1807/9) and 2 by Charles Schweychert
(active 1815), bound in green morocco, tooled in gold, with a silver clasp
bearing the monogram: 'EB'. Bequeathed by Major the Hon.
Henry Rogers Broughton, 2nd Lord Fairhaven, 1973.
PD.108–1973, folio 9.

Peter Brown was a member of the Incorporated Society of Artists and held the appointment of Painter Botanist to the Prince of Wales. He exhibited with the Society of Artists from 1766 to 1783 and at the Royal Academy from 1770 to 1791. Wilfrid Blunt, *The art of botanical illustration*, London 1950, states that Brown worked at times in a manner close to that of G.D. Ehret, whose pupil he may have been. In addition to the twenty-two drawings by Brown in this album the Fitzwilliam has an additional eight examples of his work, ranging in date from 1785 to 1787.

This is a hybrid garden clematis. Another version of the same drawing, also signed by Peter Brown is in the Fitzwilliam (PD.231–1973), but the colouring is bluer and the artist has made the composition tighter, adding a little more foliage at the top and straightening the supporting branch, which has the effect of making the finished drawing more constricted. This second version is also ornamented with a caterpillar and a Cinnabar Moth. In the drawing from the album there is a greater delicacy in the handling, and the placing of the composition on the page is more satisfactory. The leaves are more rounded, and the curve of the supporting branch enables the flower seen from behind to hang more naturally and better to fill the space. The tight curling of the tendrils helps add a sense of ornamentation to the drawing and gives it a rococo swing adding considerable verve to the design.

AMELIA FANCOURT

Active 1787

—

EPILOBIUM

Watercolour and bodycolour on paper. 481 × 300 mm.
Inscribed in graphite, lower left: 'Purple spiked willow herb / drawn from nature
by / Amelia Fancourt 1787'. From an album containing 16 drawings, bound with
soft marbled covers. Bequeathed by Major the Hon. Henry Rogers Broughton,
2nd Lord Fairhaven, 1973. **PD.128–1973, folio 11.**

Amelia Fancourt, of whom nothing is known, has been chosen to represent a characteristic example of the gifted lady–amateur. Increasingly prevalent in the eighteenth century and common in the nineteenth was the woman artist who specialised in drawing flowers. A few became professionals, the Dietzsch sisters, Mary Moser, Anne Vallayer Coster for example, but the majority never exhibited publicly and practised their craft as amateurs. Many were taught by professional botanical artists; Ehret and later, Redouté, had countless pupils, and several of them achieved a very high degree of competence. Amelia Fancourt shows an admirable sense of design and a high degree of botanical accuracy. The habit of the willow-herb, above all its tendency to curl over has been well realised, but there remains a decorative element in the drawing of the leaves, where the handling of the white highlights, representing the veins, is ornamental rather than accurate.

Epilobium (willow-herb) is an invasive, straggly plant, native to Europe. Evocative of high summer, it is unusual to find it drawn in the eighteenth century as it is generally considered a weed rather than a plant for cultivation.

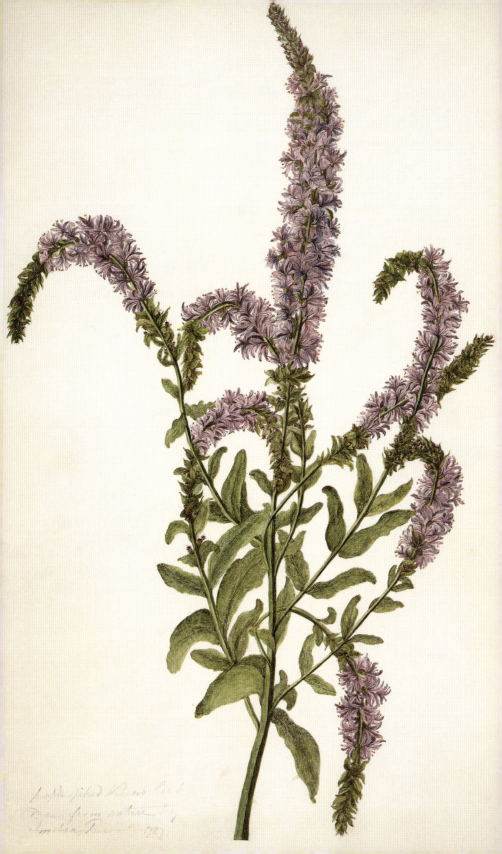

MARY COMPTON
COUNTESS OF NORTHAMPTON

Wiltshire c.1767–1843 Brighton

—

AMYGDALUS PERSICA

Watercolour and bodycolour over traces of graphite on prepared vellum.
473 × 351 mm. Inscribed in brown ink, lower right: 'Amygdalus Persica / Plena
flora / M.C. Janry. 28 1789 / No.9'. Bequeathed by Major the Hon. Henry
Rogers Broughton, 2nd Lord Fairhaven, 1973. **PD.296–1973.**

Mary Compton was the eldest daughter of Joshua Smith, M.P., of Erlestoke Park, Wiltshire. Her maternal grandfather was Nathaniel Gilbert of Antigua. She married Charles Compton, 9th Earl of Northampton, in 1787 and died in Brighton in 1843 aged 76. She was buried at Castle Ashby. Although it is impossible that she should have been taught by Ehret, who died in 1770, it is clear that she depends on his example, both for her sense of design and also for her botanical precision. Particularly effective are the roseate edges to the leaves and the exactness with which the stamens of the blossom are drawn. It is also clear from the traces of underdrawing that the shapes of the blossom were drawn in quite boldly, presumably to define their position on the vellum, and then a more specific outline was achieved in watercolour.

Amygdalus Persica, now called *Prunus dulcis*, is the common almond, native from North Africa to West Asia. Mary Compton's inscription, stating that the specimen is double flowered (*plena flora*), gives the exact date on which her drawing was executed. January is early for the almond to bloom in Britain. It is possible either that the plant is *Prunus subhirtella autumnalis* which looks very like an almond and is in blossom from November to January, that the Comptons were abroad (their eldest son had died shortly after birth in 1788) or that Mary Compton was copying someone else's drawing. The discreet 'No.9' at the bottom of the page might support this last suggestion.

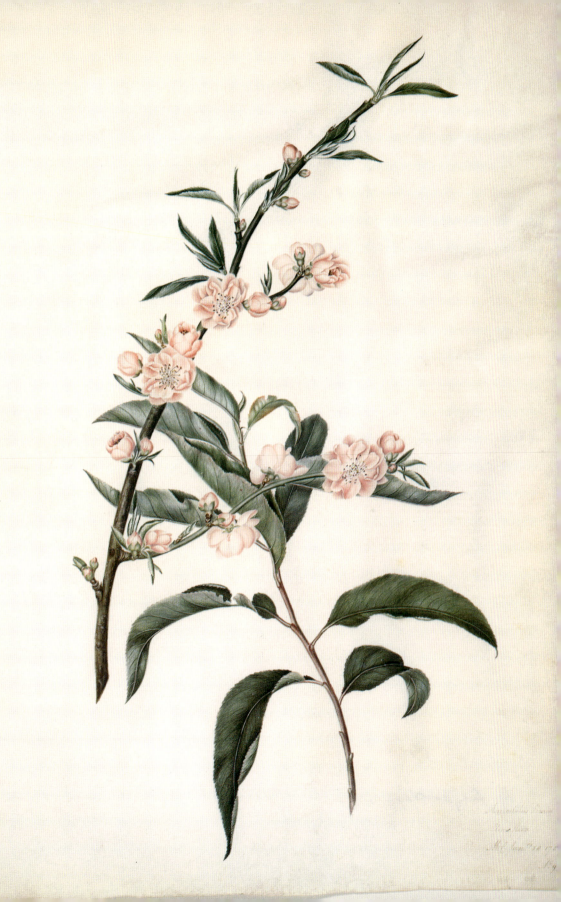

Amygdalus communis

Persica laevis

Mrs C...... del. 17..

ANTOINE BERJON

Lyons 1754–1843 Lyons

—

AN URN OF POPPIES AND
CONVOLVULUS ON A STONE LEDGE

Bodycolour and watercolour over traces of black chalk on
blue-grey paper laid down on card, pin holes to left and right of centre.
515 × 327 mm. Bequeathed by Major the Hon. Henry Rogers Broughton,
2nd Lord Fairhaven, 1973. **PD.191–1973.**

Berjon was the son of a butcher. He started to study medicine but soon entered the silk factory at Lyons as a designer. He went to Paris in 1794, exhibiting at the Salon in 1798 and 1799, and returned to Lyons around 1810. He was elected Professor of Flower Design at the Ecole des Beaux-Arts at Lyons in 1810 and remained in post until 1823. He died in Lyons in 1843.

Berjon is much admired today for the simplicity of his compositions, exemplified here. The solid mass of the urn is in effective contrast to the delicate colouring of the poppies and convolvulus. The white poppies and the red one on the right appear to be *Papaver somniferum* (opium poppies); the pink poppy with the white edge is probably a type of *Papaver rhoeas* (field poppy). The convolvulus is the ordinary European *Convolvulus althaeoides*.

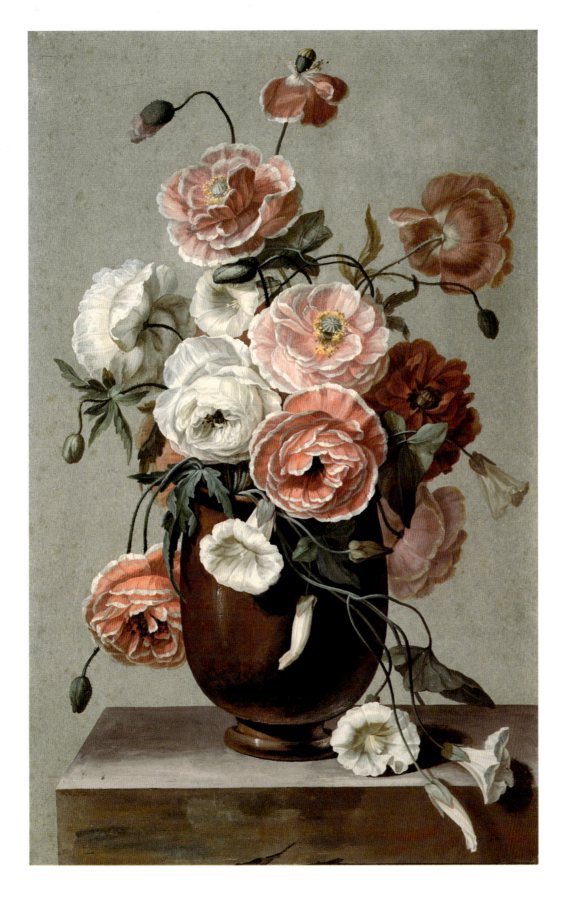

JAMES SOWERBY

London 1757–1822 Paris (?)

—

IRIS PERSICA

*Watercolour, heightened with white over graphite, bordered on all sides with a
line of graphite. 459 × 285 mm (drawn area: 282 × 179 mm). Inscribed by the artist,
below, in graphite: 'Iris persica'; upper right, in another hand: 'Bot Mag Vol (1)'; and '63'.
From an album bound in quarter red morocco, gilt tooled, the spine lettered: 'Hortus Sylva
Montis', containing 100 drawings, all by Sowerby. Bequeathed by Major the Hon. Henry
Rogers Broughton, 2nd Lord Fairhaven, 1973.* **PD.105–1973, folio 63.**

A pupil of the marine painter, Richard Wright (1735–1774), Sowerby was the
father of a distinguished family of botanical draughtsmen and engravers. He
drew over 2,500 illustrations for *English Botany* 1790–1814. From 1787 he
worked for William Curtis (1746–99), Praefectus Horti and Demonstrator to
the Society of Apothecaries at Chelsea, on the *Botanical Magazine*. For him he
also drew and engraved plates for the fifth fascicule of the *Flora Londinensis*, a
compilation of all the flowers that grew within ten miles of London. He made
drawings for Smith's *Icones pictae plantarum rariorum* (1790–3), for Aiton's
Hortus Kewensis (1789), for his own *An easy introduction to drawing flowers accord-
ing to nature* (1788) and *Flora luxurians* (1789–91). After 1791 he worked on
Coloured figures of English fungi and, after 1806, on engraving of the plates for
Sibthorp's *Flora Graeca*. A genus of Australian lilies was named after him,
Sowerbaea, and also a whale, *Mesoplodon sowerbiensis*.

The drawing shows the *Iris persica* with a study of bulbs with inflorescence
and immature leaves. It was engraved as plate 1 of volume 1 of William Curtis'
Botanical Magazine published on Feb. 1 1787. The first part of the Magazine
contained three plates, and three thousand copies were sold at one shilling
each. Its aim was to illustrate and describe 'the most Ornamental FOREIGN
PLANTS, cultivated in the Open Ground, the Green-House, and Stove.' The
best information respecting their culture was added and the illustrations were
all drawn from the living plant. It has continued publication, almost without
interruption, until the present day.

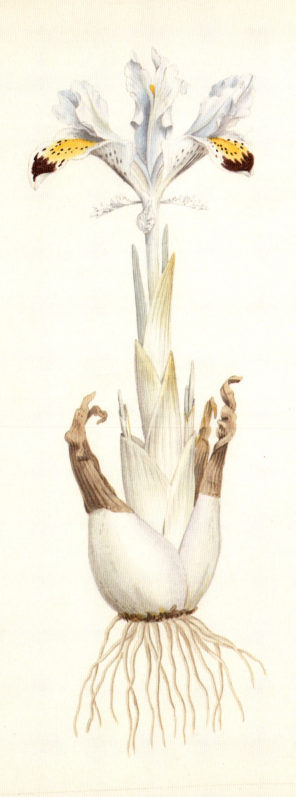

Iris persica

JAMES SOWERBY

London 1757–1822 Paris (?)

●

ERYTHRONIUM DENS CANIS

Watercolour and gum arabic over graphite, bordered on all sides with a line of graphite. 459 × 285 mm (drawn area: 303 × 212 mm). Inscribed by the artist in graphite, below: 'Erythronium Dens Canis'; numbered, upper right: '32'. From an album bound in quarter red morocco, gilt tooled, the spine lettered: 'Hortus Sylva Montis', containing 100 drawings all by Sowerby. Bequeathed by Major the Hon. Henry Rogers Broughton, 2nd Lord Fairhaven, 1973. **PD.105–1973 folio 32.**

Erythronium dens canis (dog's-tooth violet) is found in Central Europe through Asia to Japan. The drawing shows a study of the plant with fleshy rootstock and single stem with leaves and a flower. On the lower right is a detailed study of an individual stamen and on the lower left a detail of the ovary with style and stigmas. The flowers in this book were drawn about 1787 from specimens grown in the garden of William Curtis' friend, J.C. Lettsom, at Grove Hill (*Sylva montis*), Camberwell. Sowerby was remarkably prolific and hard working. His drawings have a fine attention to botanical detail and are so clear that it is easy to transfer them to printed form. Despite the number of projects in which he was involved he still needed to take in pupils and rely on teaching and portraiture for his living. His best known pupil was Mary Wollstonecraft Godwin, author of the *Vindication of the rights of women*.

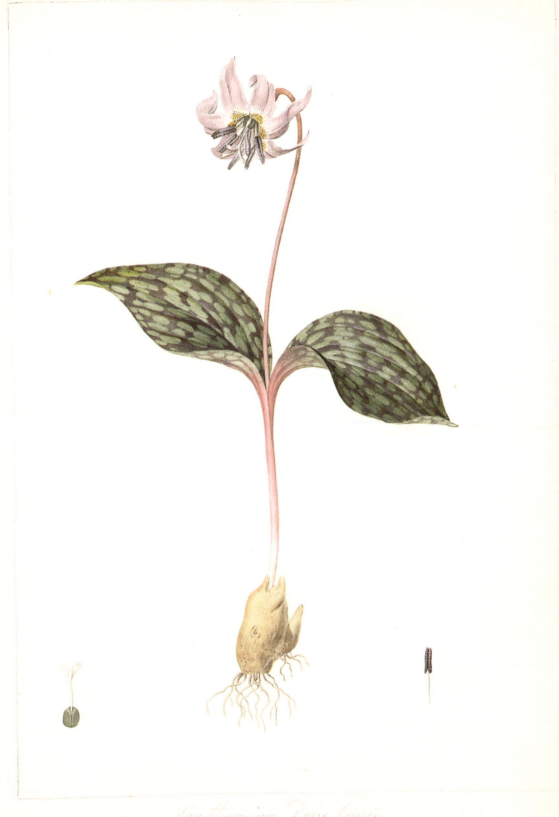

PIERRE-JOSEPH REDOUTÉ

St Hubert 1759–1840 Paris

—

MAGNOLIA MACROPHYLLA

Watercolour and gum arabic over graphite on prepared vellum, bordered on all sides in brown and gold. 476 × 338 mm. Numbered in gold, upper right: '33'; signed and dated, lower left: 'P. J. Redouté.1811'; inscribed, below: 'Magnolia Macrophylla'. From an album of 72 drawings bound in red morocco, tooled in gilt and embossed with the arms of the Orléans family. Bequeathed by Major the Hon. Henry Rogers Broughton, 2nd Lord Fairhaven, 1973. **PD.122–1973, folio 33.**

Redouté moved to Paris in 1782, where he attracted the attention of the wealthy botanist, Charles Louis l'Héritier de Brutelle, who commissioned more than fifty plates for his *Stirpes novae* (1784–5). L'Héritier went to London in 1786 and Redouté joined him, collaborating on his *Sertum anglicum* (1788), a study of rare plants growing at Kew. Redouté was appointed draughtsman to the Cabinet of Marie-Antoinette just before the Revolution. In 1793 he was appointed to the Jardin des Plantes and in 1805 the Empress Josephine named him her flower painter. He was responsible for the illustrations in the two volumes devoted to recording the rare plants she grew in the gardens at Malmaison. His most famous works are the eight volumes of *Les Liliacées* (1802–16) and *Les Roses* (1817–24). Redouté had many pupils. Despite his reputation he was prodigal with money and died in poverty.

Painted for the *Descriptions de plantes rares cultivés à Malmaison et à Navarre* (published in Paris, 1813). The *Magnolia macrophylla* is a native of the South East United States, introduced into Europe in 1800. It has larger leaves and flowers than any other deciduous tree or shrub which is hardy in the British Isles. Redouté's design brilliantly displays the glaucous effect of the leaves which can grow to two feet in length, and, by extracting one petal, shows the marvellous pinkish purple centre of the flower. His work for his Imperial patron produced his most spectacular and sensitive drawings.

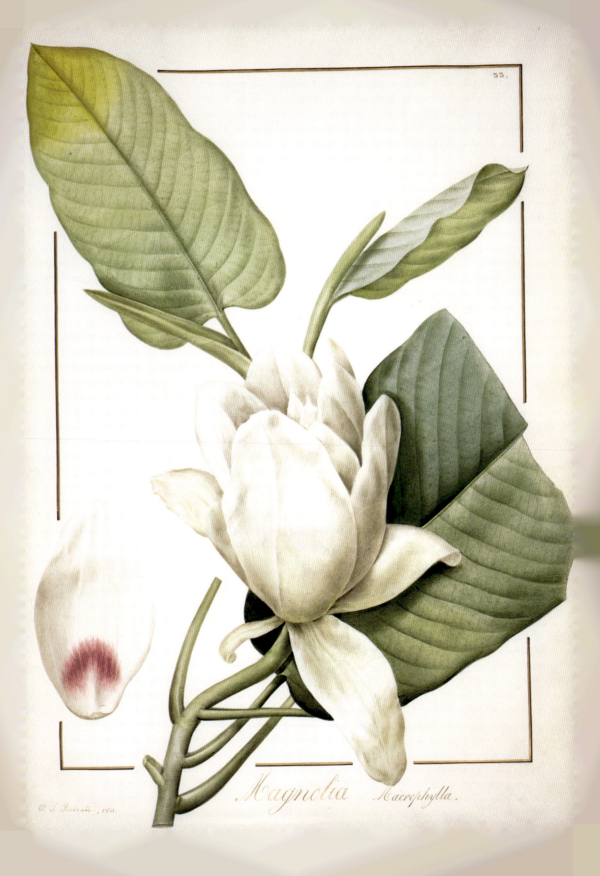

33.

Magnolia Macrophylla.

PIERRE-JOSEPH REDOUTÉ

St Hubert 1759–1840 Paris

—

PAEONIA SUFFRUTICOSA

Watercolour with gum arabic over graphite on prepared vellum, bordered on all sides in brown and gold. 460 × 336 mm. Numbered in gold, upper right: '23'; below right: 'I'; signed and dated, lower left: 'P. J. Redouté 1812'; inscribed below: 'Paeonia Moutan.var.B.' From an album of 72 drawings bound in red morocco, tooled in gilt and embossed with the arms of the Orléans family. Bequeathed by Major the Hon. Henry Rogers Broughton, 2nd Lord Fairhaven, 1973. **PD.122–1973, folio 23.**

Paeonia *suffruticosa* is the scientific name for the moutan, a native of China, where it has been cultivated for many centuries. As early as C.E.536 a Chinese author stated that the original habitat of the wild plant was in eastern Szechuan and Shensi in western China. The large flower appealed to Chinese taste and by 700 many varieties were known. It was exported to Japan *c*.734, where many new varieties have been bred. No plants of Japanese origin were sent to Europe before 1844 so Redouté must have drawn a specimen of Chinese origin. The first variety to reach Europe was planted at Kew in 1789 by Sir Joseph Banks. This was said to be very double, magenta at the centre, fading to a lighter tint at the outside, and by 1829 was reported as eight feet high and ten feet across; it was destroyed in 1842. It is possible that the specimen drawn for the Empress Josephine came from this stock. Certainly the number of petals represented show that this is a double paeony (the wild moutan has twelve to fifteen petals in two rows). Redouté is at his most brilliant in this drawing. The placing of the flower on the page and the richness of tonal variation are both extraordinarily effective. Close inspection of the under-drawing reveals a preliminary geometric layout with occasional marks made by compasses, which gives some idea of Redouté's 'scientific' approach to the drawing of flowers. The graphite drawing of the seed head on the right shows the artist's customary delicacy.

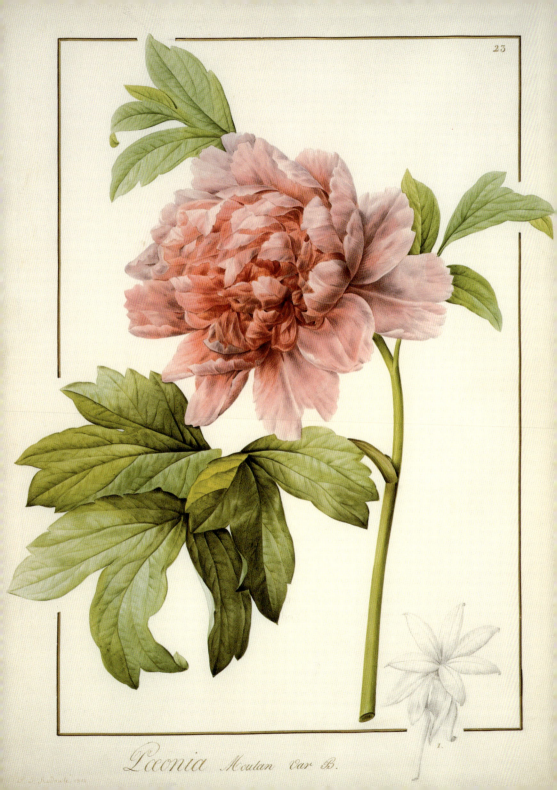

Pæonia Moutan Var B.

FRANCIS BAUER

Feldsberg 1758–1840 London Kew

—

A SURROUND OF MIXED FLOWERS FRAMING
A MANUSCRIPT NOTE BY SIR JOSEPH BANKS

Watercolour over graphite. 135 × 208 mm. Inscribed in the centre in brown ink by Sir Joseph Banks: 'March 30 1814 / May the much honord Flower of / Strelitz the budding myrtle of Affection, the / Elegant Emblem of Remembrance, & the / sacred symbol of Recollection, Perpetually / encircle the Reverd Name of ELIZA. / May Her Royal Highness, under / the mild and chearing influence of our Guiding / Star, Ever Continue to Enjoy that Happiness / which Superior Talents, unexampled affability / and Angelic Virtue, never Fail to bestow; is / the heartfelt wish of one, who in Token / of his Sincerity, has subjoined his name, / his seal & his flower. / Jos:Banks.' Bequeathed by Major the Hon. Henry Rogers Broughton, 2nd Lord Fairhaven, 1973. PD.174–1973.

Franz Bauer was born at Feldsberg near Vienna. A precocious draughtsman, his *Anemone pratensis* was engraved and published when he was only thirteen. He came to England in 1790 at the instigation of Sir Joseph Banks (1743–1820), the President of the Royal Society. Banks secured George III's approval for Bauer's appointment as permanent draughtsman to the Royal Gardens at Kew. Bauer remained there for nearly fifty years. He gave lessons in botanical drawing to Queen Charlotte and the Princess Elizabeth. He became a highly skilled botanist and his microscopic drawings were as famous as his flower studies.

The drawing is a conceit to be sent to the Princess Elizabeth (1770–1840), 3rd daughter of George III and Queen Charlotte, who married the Prince of Hesse-Homburg. Banks' note explains the choice of imagery. The *Strelitzia* (bird of paradise) was named in honour of Queen Charlotte, who came from Mecklenburg-Strelitz, the myrtle behind it is for 'affection'. Forget-me-nots are for 'remembrance' and 'recollection'. The other floral tributes are heartsease and roses, with a final use of the *Banksia* as a punning tribute to Banks himself, after whom the plant was named.

March 30 1914

May the much honor'd Flower of
Thelitz, the budding Myrtle of Affection, the
Elegant Emblem of Remembrance & the
Sacred Symbol of Recollection perpetually
Encircle the Revered Name of Eliza F.

May Her Royal Highness, under
the mild & cheering influence of our Guiding
Star, Ever continue to Enjoy that Happiness,
which Superior Talents, incomparable affability
and angelic Virtue never fail to bestow, is
the heartfelt wish of one who in token
of his sincerity, has subjoin'd his name
& his Seal & his Element. Jos: Banks

FERDINAND BAUER

Feldsberg 1760–1826 Hietzing

~

MALVACEAE SPECIES

*Bodycolour and watercolour on prepared vellum, bordered on all sides
in gold. 451 × 335 mm. From an album of 17 drawings, bound in brown leather.
The spine tooled in gold: 'BOTANICAL DRAWINGS / FERDINAND
BAUER'. The cover tooled in gold with the Royal Arms. Bequeathed by
Major the Hon. Henry Rogers Broughton, 2nd Lord Fairhaven, 1973.*
PD.121–1973 folio 10.

Like his elder brother, Franz, Ferdinand Bauer showed a precocious talent. At
fifteen he painted for the Abbot of Feldsberg a large number of highly finished
flower studies which passed into the Liechtenstein Collection. In 1786 he accom-
panied, as draughtsman, John Sibthorp, Sherardian Professor at Oxford, on
his prolonged botanical survey of the Aegean, which resulted in Sibthorps'
Flora Graeca (10 volumes 1806–40). In 1800 he embarked on Matthew Flinders'
five year voyage of exploration to Australia. On his return to England he began
illustrations for Robert Brown, the botanist who had accompanied the
Flinders exhibition. Unfortunately Brown could not find a financial backer for
his *Illustrationes florae novae Hollandiae* so Bauer left England and returned to his
native Austria, where he settled at Hietzing, near Schönbrunn. There he com-
pleted his series of finished drawings of Australian plants and animals (see
Marlene F. Norst, *Ferdinand Bauer. The Australian natural history drawings*, 1989).
His work was enormously influential, a model for later explorer artists.

Malvaceae species is a member of the mallow family. This may be *Malva alcea*
which was imported to England from Italy in 1797, but could have been seen
by Bauer when he was in the Aegean with John Sibthorp. The seed-head is
a particularly characteristic example of Bauer's accuracy and brilliance of
draughtsmanship.

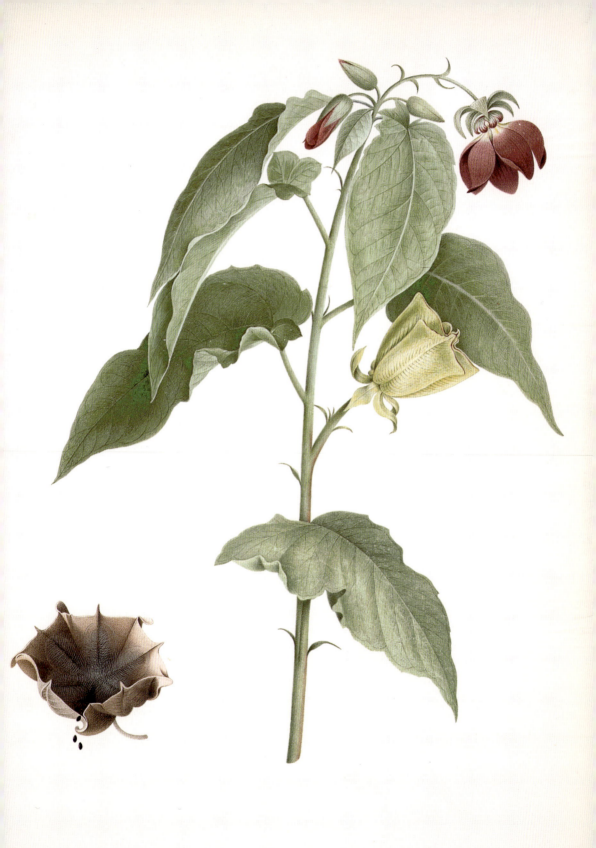

ZACHARIE-FÉLIX DOUMET

Toulon 1761–1818 Draguignan

—

SPRING AND SUMMER FLOWERS
SEEN BEYOND A BALUSTRADE, WITH A VIEW
ACROSS A RIVER TO A DISTANT CASTLE

*Bodycolour and watercolour, bordered on all sides by a line
of black wash. 328 × 228 mm. Signed and dated in brown ink, lower left
and lower right: 'Z-F Doumet Febr 2 1795'. Bequeathed by Major the Hon. Henry
Rogers Broughton, 2nd Lord Fairhaven, 1973.* **PD.389–1973.**

Doumet was the son of the Toulonese genre painter, Gaspard Doumet (1720–1795). Trained as a marine artist, he left Toulon for exile in Corsica, where he stayed for three years before moving on to Lisbon. He returned to Toulon in 1806.

Possibly a design for painted wall-paper, the plants depicted include: honeysuckle, poppies, paeonies, tulips, sun-flowers, roses, delphiniums, hollyhocks, and morning glory. This was painted when Doumet was in Portugal and may show an idealised view across the Tagus.

47

JAN FRANS VAN DAEL

Antwerp 1764–1840 Paris

—

BOUQUET OF MIXED FLOWERS

Black and white chalks on blue paper, faded grey. 466 × 364 mm.
Signed with initials and dated, lower right: 'V.D./VII'. Bequeathed by Major
the Hon. Henry Rogers Broughton, 2nd Lord Fairhaven, 1973.
PD.308–1973.

Van Dael studied at the Antwerp Academy from 1776 and left Flanders for Paris in 1786, where he began as a decorative painter of arabesques, faux-bois and ornaments, probably in collaboration with Piat Sauvage (1744–1818). He then turned to flower painting under Gérard van Spaendonck (1746–1822), another Fleming who had come to find fame and fortune in Paris. He first exhibited at the Salon in 1793, coming under Imperial and Royal patronage and receiving many honours. In 1825 he was made a Chevalier of the Légion d'Honneur. Van Dael was involved in decorative schemes for the interiors of several châteaux and his designs were used at the Sèvres porcelain works. He had a studio at the Sorbonne and, like Redouté, taught extensively. Apart from this drawing the Fitzwilliam has a fine painting by van Dael, dated 1817 (PD.19–1987) and about twenty miniature paintings of flowers. He rivalled van Spaendonck for the title of the most celebrated and influential flower painter in Paris.

Drawn in 1799 (Year Seven of the New Regime), the flowers include jonquil, Crown Imperial, roses and tulips. The variety achieved with only black and white chalks is enhanced by the artist's adept use of the colour of the paper on which he has drawn. Here the careful 'sparing' (i.e. blank areas used to delineate form) adds a third tonal dimension. Despite the breadth of van Dael's handling (no evidence of the miniaturist here) the drawing is of remarkable subtlety.

PANCRACE BESSA

Paris 1772–1846 Ecouen

—

POTTED AURICULA

Watercolour and gum arabic over traces of graphite. 365 × 284 mm.
Signed and dated in graphite on the base of the left of the pot: 'Bessa 1817'.
Bequeathed by Major the Hon. Henry Rogers Broughton,
2nd Lord Fairhaven, 1973. **PD.199–1973.**

Bessa is said to have studied with Gérard van Spaendonck (1746–1822) in Paris. He was also one of only seven men who studied with Redouté (the rest of his pupils were women). With him he worked on Bonpland's *Description des plantes rares cultivées à Malmaison et à Navarre* (1812–17), being responsible for nine of the plates. Like Redouté he was an early practitioner of stipple engraving, as witness his *Fleurs et fruits* of 1808. He exhibited watercolours of flowers at the Paris Salon from 1806 to 1814 and in 1816 was appointed flower painter to the Duchesse de Berry. In 1820 he became her drawing master. In 1823 Bessa succeeded van Spaendonck jointly with Redouté as painter on vellum to the Musée d'Histoire Naturelle in Paris. He retired to Ecouen between 1831 and 1835, where he died. His contemporary, Landon, wrote of him: 'So far as flower and fruit pieces are concerned, there seems to be a strong competition between Redouté and Bessa, being both equally talented, hard-working and successful.'

Long cultivated for display, this type of *Primula* is an old garden flower probably derived from hybrids between two European alpine species, *Primula auricula* and *Primula rubra*. The finest flower painters have a splendid understanding of design. Here the massive clustering of the leaves is superbly set off by the simplicity of the earthenware pot, and botanical accuracy is combined with a flair for composition. This less rigidly botanical drawing must be characteristic of the examples sent by Bessa for exhibition at the Salon.

GERMAN SCHOOL

c. 1820

—

WHITE FIELD ROSE AND DOG ROSE

Watercolour and bodycolour over traces of graphite. 365 × 237 mm.
Inscribed, lower left: '1. Feld-Rose weisse. / Rosa campestris alba / 2. Szude Rose / Rosa
Canina.' From an album of 16 drawings bound in brown leather, tooled in gold, the
spine with a label: 'ELIZABETH BLACKWELL / FLOWER DRAWINGS'
and dated: 'c.1700'. Bequeathed by Major the Hon. Henry Rogers Broughton,
2nd Lord Fairhaven, 1973. **PD.98–1973, folio 14.**

The old attribution to Elizabeth Blackwell (active 1737) cannot be sustained. The paper on which the roses are drawn is early nineteenth century and as both the inscriptions on the drawings in the album are in German and the technique of delineating shadow to give a three-dimensional appearance to the plants is also found in Germany, it is plausible to attribute the drawings to that school. The white field rose (*Rosa silvestris alba*) is probably *Rosa spinosissima*, the Burnet rose, which has an extremely spiny stem and bears hips which are purple-black, like those at the top right of the drawing. *Rosa canina*, the dog rose, is the wild briar, common to Europe and Great Britain. It is regularly seen in hedgerows in southern England, and it bears glossy red egg-shaped hips, like those at the bottom right of the drawing. The artist is clearly a professional and the evidence of the other drawings is that he/she was as adept at painting vegetables, moths and butterflies as flowers. The slight traces of grey on the petals of the white rose should be read as white highlights. The artist has used lead white to accentuate the white of the flower, but a chemical reaction has taken place with the air so that the pigment has changed to grey.

1. Feld-Rose weiße.
Rosa Campestris alba
2. Hunds-Rose.
Rosa Canina.

50

HENRIETTA GEERTRUIDA KNIP

Tilburg 1783–1842 Haarlem

-

SELENICEREUS GRANDIFLORUS

*Watercolour and bodycolour over graphite, bordered on all sides by
a line of graphite. 498 × 360 mm. Inscribed in graphite, above: 'CEREUS';
signed in graphite, lower left: 'Henrietta Knip'. Bequeathed by Major the Hon.
Henry Rogers Broughton, 2nd Lord Fairhaven, 1973.* **PD.729–1973.**

A daughter of Nicholas-Frederick Knip the Elder (1742–1809), Henrietta Knip came from a family of artists. Her father, known for his still lifes of flowers and fruit as well as for landscape paintings, practised at Tilburg until he went blind, c.1795. Henrietta's three brothers adopted landscape painting, but she preferred to paint flowers. Presumably her early training was with her father, but later she went to Paris where she studied from 1802 to 1805. Her teachers included Gérard van Spaendonck (1746–1822) and Jan Frans van Dael (1764–1840). Subsequently she worked in Haarlem where she died. During her lifetime she had considerable acclaim and exhibited widely in France, Germany, Flanders, Amsterdam and The Hague.

Selenicereus grandiflorus, the Night-flowering Cereus, is known popularly as 'The Queen of the Night'. A cactus, native to Jamaica, it is known best from the print in R. J. Thornton's *Temple of Flora* (London, 1807), where it is portrayed growing up a tree by a river, with a moonlit and unmistakably English church tower in the background. Henrietta Knip probably knew this print as it struck the Romantic imagination and had a wide circulation, but she was equally likely to have known Ehret's well-known drawing of the same plant, drawn in 1744 and engraved in 1752. Like them both, Knip has used some artistic licence in her treatment of this plant, concentrating on the bloom of the flower, thereby exaggerating its proportions with reference to the deeply ridged main stem.

CEREVS

Hanriette Keip

PATRICK NASMYTH

Edinburgh 1787–1831 Lambeth

—

RUMEX OBTUSIFOLIUS

Watercolour over traces of graphite. 295 × 211 mm.
Bequeathed by J. R. Holliday, 1927. **No.1404.**

Patrick Nasmyth studied with his father, Alexander Nasmyth (1758–1840). In 1808 he moved from Edinburgh to London and established himself as a landscape painter. He exhibited at the Society of Associated Artists in Edinburgh from 1808 to 1814 and at the Royal Institution and the Scottish Academy. In 1811 he exhibited for the first time at the Royal Academy; he also exhibited at the British Institution and was a founder member of the Society of British Artists. He frequently went on sketching trips to the North and South Downs and elsewhere in the Home Counties, and in addition to his many landcapes inspired by the Dutch masters, notably Hobbema and Ruisdael, he painted a number of careful nature studies. His premature death at his lodgings in Lambeth was caused by a severe cold caught as a result of sketching willow trees on the banks of the Thames and standing on wet ground.

Rumex obtusifolius is better known by the common name of broad dock. This is one of a pair of watercolours bequeathed in 1927 by the great collector and advocate of British drawings, J. R. Holliday. The other shows *Arctium* or burdock and has a similar palette, one which Nasmyth shared with Peter de Wint (1784–1849). Watercolours by Nasmyth are rare. These were clearly done 'from nature', presumably on one of Nasmyth's regular sorties into the countryside around London. A date of c.1810 has been suggested.

52

LUCY CUST

Active c.1815

●

PAEONIA SUFFRUTICOSA

*Watercolour and traces of bodycolour with gum
arabic over traces of graphite, heightened with lead white, reduced in
part to black, and scraping out. 540 × 690 mm. Signed and dated in brown ink,
lower right: 'Lucy Cust 1815'. Bequeathed by Major the Hon. Henry Rogers
Broughton, 2nd Lord Fairhaven, 1973.* **PD.307–1973.**

Lucy Cust was one of the five daughters of Brownlow Cust, 1st Baron Brownlow (1744–1807). Her status is that of amateur, but the technical ease with which she has drawn these paeonies shows that she should rank with the professionals. She is clearly inspired by both Ehret and Redouté.

Paeonia suffruticosa, otherwise known as *Paeonia moutan var.B.*, the moutan or Japanese tree paeony, is a native of China. It has been cultivated for many centuries and many colours have been developed both in China and Japan. This is close to, and possibly identical with the wild species, which was found growing in Kansu by Purdom and Farrer in 1914. Lucy Cust's drawing is particularly brilliant in her sparing of the paper. In the blossom on the left of the sheet, the green of the surrounding foliage and light streaking of purple towards the centre of the flower give the illusion that the rest of this section of the drawing has pigment, but there is none. The specimen she has drawn was probably brought to England in 1802 by Captain James Prendergast and first flowered in the garden of Sir Abraham Hume at Wormley Bury, Hertfordshire in 1806.

NATHALIE D'ESMÉNARD

Paris 1798–1872 Nice

●

NOISETTE ROSE

Watercolour and bodycolour with gum arabic over traces
of graphite on prepared vellum. 351 × 259 mm. Signed and dated in graphite,
lower right of centre: 'Nathalie 1823'. Bequeathed by Major the Hon. Henry
Rogers Broughton, 2nd Lord Fairhaven, 1973. **PD.566–1973.**

Nathalie-Elma d'Esménard was the acknowledged illegitimate daughter of
Joseph-Etienne d'Esménard (1767–1814) and Jeanne-Adolphe Kalegraber, who
married in 1801. Nathalie studied with Redouté (1759–1840), whose portrait
her younger sister, Ines, painted in 1834. One of the best of Redouté's pupils,
she exhibited at the Paris Salons of 1822 and 1827. She married first Baron
Antoine Renaud, thereafter signing her watercolours 'Baronne Renaud'. In
1843 she married again. Her second husband was Pierre de Ricordy, who came
from Nice, where she settled.

The Noisette Rose is a cross between *Rosa chinensis* and *Rosa moscheta*. It
was produced by Philippe Noisette of Charleston, South Carolina, and intro-
duced to Europe early in the nineteenth century. This is an exact copy of
Redouté's painting of a Noisette Rose, entitled 'Rosier de Philippe Noisette'
and reproduced in his *Les roses . . .*, Paris, Didot 1817–24, 3 volumes. In the
Redouté the traces of pink are more pronounced on the rosebuds. It was a reg-
ular practice for Redouté's pupils to copy drawings by their master and
Nathalie has succeeded brilliantly in balancing white on white in this expert
example.

Nathalie 1823

JOHN LINDLEY

Catton 1799–1865 Turnham Green

•

DORYANTHES EXCELSA

Watercolour with traces of bodycolour over graphite. 704 × 508 mm.
Inscribed in graphite, signed with initials and dated, verso: 'Dorianthus excellsa –
Botanic Name / Minmi – Natives name /Gigantic Lilly – So call'd in New South Wales /
The View is of a very high & extensive Mountain called the / Sugar-Loaf – taken from the
North Side of Reeds Mislake / which is the name and part of the Water represented in the
Drawing / about 8 miles from Newcastle / J. L Delint 1823 / The Height of this Plant was
Twenty Three feet from the / Top to the Ground in general is found in valleys near /
the Swamps –.' Bequeathed by Major the Hon. Henry Rogers Broughton,
2nd Lord Fairhaven, 1973. **PD.757–1973.**

John Lindley was born in Norfolk, the son of a nurseryman, George Lindley. He became an assistant in Sir Joseph Banks' library in 1819. In 1822 he was Garden Clerk to the Horticultural Society of London, Assistant Secretary in 1827 and Secretary from 1858 to 1863. He was Professor of Botany at University College, London from 1829 to 1860 and Praefectus of the Chelsea Physick Garden. In 1838 he prepared a report on the Royal gardens at Kew which led to the creation of the Royal Botanic Gardens. He was a prolific author and in 1841 founded *The Gardener's Chronicle* with Sir Joseph Paxton. The Lindley Library at the Royal Horticultural Society is named for him.

Doryanthes excelsa is a native of New South Wales, from the family of Amaryllidaceae; its common name is the Gymea Lily. As the inscription points out this specimen grew to a height of twenty-three feet in a swampy valley near Newcastle. The lake on the left and the mountain in the background are identified as Reed's Mislake (*sic*) and Sugar-loaf Mountain. Lindley never travelled to Australia so this drawing and its informative inscription must be based on someone else's sketch done on the spot. The flower blooms in spring and drips so heavily with honey that it is frequently damaged by birds in their eagerness to extract the sweetness.

ALFRED CHANDLER

London 1804–1896 London

&

CAMELLIA JAPONICA ECLIPSIS

Watercolour and bodycolour with gum arabic over graphite. 367 × 284 mm.
Inscribed in graphite, below: 'Camellia Japonica eclipsis' and numbered, upper right:
'30'. From a portfolio of 32 drawings of Camelliae, bound in gold-striped green fabric
and boxed in green morocco gilt, tooled and stamped in gold on the spine:
'DRAWINGS / OF / CAMELLIAS / ALFRED / CHANDLER'. *Bequeathed by*
Major the Hon. Henry Rogers Broughton, 2nd Lord Fairhaven, 1973.
PD.100–1973 folio 21.

Alfred Chandler was a Vauxhall nurseryman by trade. He painted flowers and fruit. He exhibited at the Royal Academy in 1825. Of the thirty-two drawings in the Fitzwilliam, twenty-eight were published by Chandler and W.B. Booth in 1831 in *Illustrations and descriptions of the plants which compose the natural order camelliae*. Three of the others were intended for a second volume, to have been published in 1837; four prints by E.S. Wendall were issued for this project, but it was never completed. The last drawing in the portfolio is dated 1838.

 Camellia japonica eclipsis is still listed as a variety of camellia available for gardeners. Camellias are native to China, India and Japan, and from c.1819 they were in considerable demand for cultivation in Europe. Although they will grow outside, many gardeners grew them in glasshouses and the smartest men-about-town wore them as a buttonhole all year round, like the 'perpetual' carnation. *Camellia japonica* is the common camellia native to Japan and Korea and there are very many varieties, even one named after Chandler, whose book did much to promote their popularity. Stylistically his drawings are a little crude and there is evidence of a rigid geometric system in the underdrawing which can sometimes give a wooden appearance to the finished work. However in this example he has emphasised brilliantly the glossy, dark green, leathery leaves of the species by a judicious application of gum arabic and with a delicate wash of grey he has controlled the outline of the white petals against a white background, always one of the most difficult achievements for a botanical draughtsman.

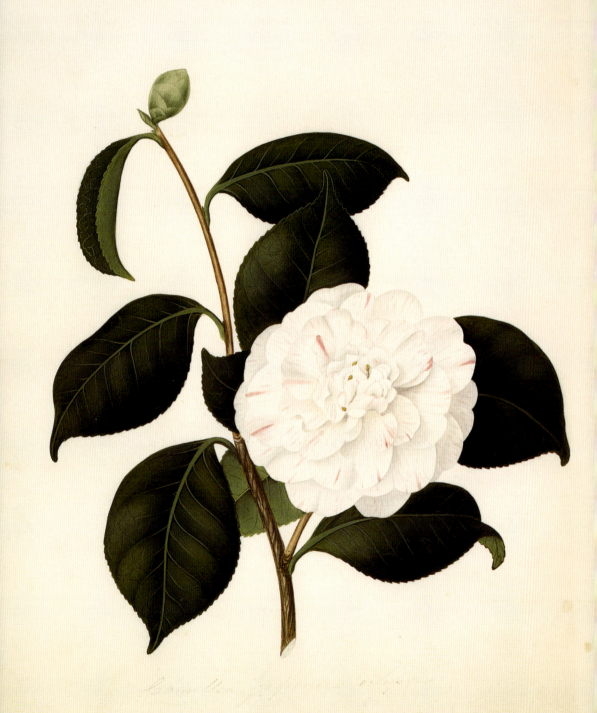

Camellia japonica alba

ISABELLA SELWIN

Active in England 1826–1831

—

HELIOCEREUS SPECIOSUS

Watercolour with gum arabic over traces of graphite. 385 × 302 mm.
Signed and dated in red ink at the base of the right hand stem: '1831/I.T.& Is Selwin'.
From an album of 28 watercolours, signed variously 'Isabella Selwin, I.T., I.T.Ibbetson,
I.T.S., I.T.Selwin' and dated between 1826 and 1831, bound in light brown leather with
stamped decoration round the edges of the front and back boards. The spine is stamped
in gilt and on a green leather inset: 'FLOWERS / FROM NATURE / ISABELLA
SELWIN'. Bequeathed by Major the Hon. Henry Rogers Broughton,
2nd Lord Fairhaven, 1973. **PD.97–1973, folio 26.**

Nothing is known of Isabella Selwin. Despite the variation in signature all the drawings in this album are stylistically compatible with one another. Perhaps Isabella Selwin and I.T. Ibbetson are the same person, although it would be distinctly odd, and show an idiosyncratic sense of humour, for one person to sign the same drawing with two different signatures.

The drawing included is characteristic of the better type of amateur drawing done by women in the first half of the nineteenth century. Although not so polished or professional as Lucy Cust or Nathalie d'Esménard, it shows a distinct flair for the medium of watercolour combined with a real attempt at botanical accuracy. The lettering on the spine of the album states that the drawings are 'done from nature' and all the flowers included in it look as though they were studied from original specimens. One (folio 2), showing a *Cyclamen repandum*, is inscribed 'home', so one can assume that Isabella Selwin had access to flowers in a garden.

Heliocereus speciosus comes from Mexico and central America. The open funnel-shaped flowers are eight inches long and six inches wide; they appear in April and May and remain open for several days. Traditionally, when grown in Europe, these plants are supported by canes, and one is visible here between the two stems, which in the wild clamber or grow prostrate.

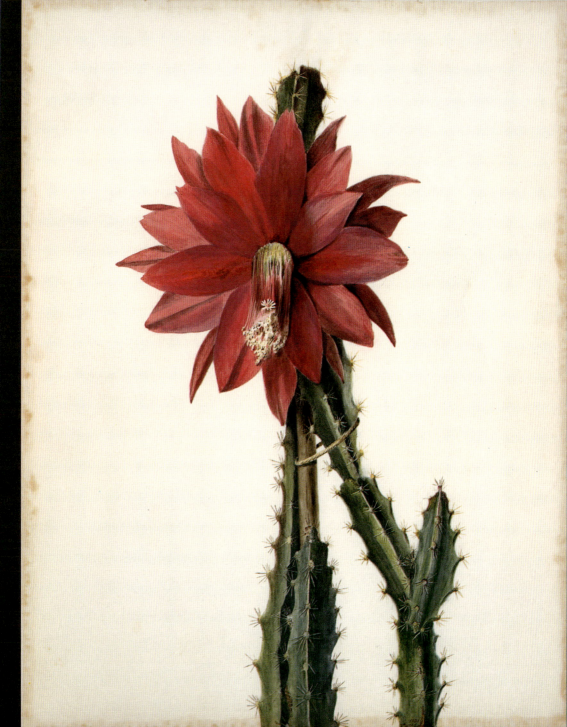

CHARLES ROSENBERG

Active in London 1818–1851

—

ROSA × CENTIFOLIA 'BULLATA'

Watercolour and gum arabic over graphite. Approximately circular,
maximum diameter 425 mm. Signed with initials and dated with the brush,
lower centre: 'CR 1851'. Bequeathed by Major the Hon. Henry Rogers
Broughton, 2nd Lord Fairhaven, 1973. **PD.921–1973.**

Charles Rosenberg is probably to be associated with Charles Rosenberg Junior, who lived in Lambeth, was a poet as well as a painter and first exhibited at the Royal Academy in 1818. Between 1844 and 1848 he again exhibited at the Academy and also at the British Institution and Suffolk Street. He was the author of guides to the Royal Academy Exhibitions of 1847 and 1848. Charles Junior was a son of Thomas Elliot Rosenberg (1790–1835), the miniaturist and landscape painter, whose father, Charles Rosenberg of Bath (1745–1844), a native of Hanover, was best known as a silhouettist.

Rosa × centifolia 'Bullata' is a cabbage rose, with leaves crisped like lettuce. Here it is shown growing over a fence alongside a country house built in the late Elizabethan style. The butterfly on the left is probably a Bath White (*Pontia daplidice*) and that on the right is an Orange Tip (*Anthocharis cardamines*). The drawing exemplifies the 'Romantic' approach to composition and the mood of the High Victorian period.

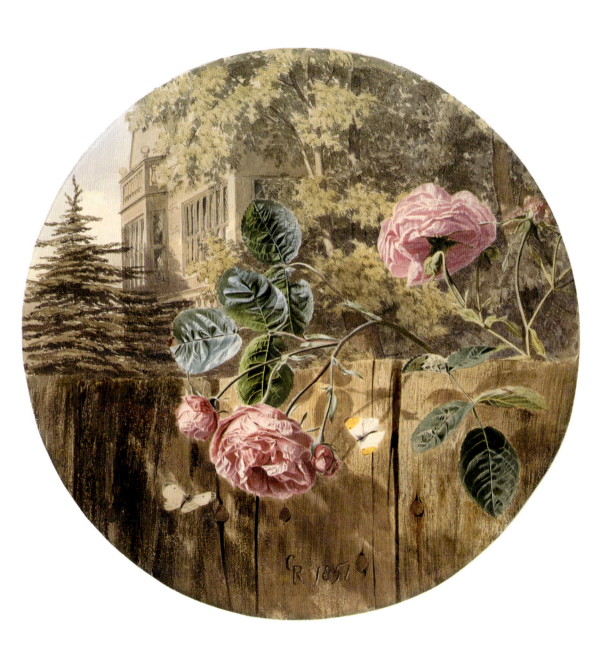

CORNELIUS B. DURHAM

Active in London 1825–c.1876

—

CATTLEYA DOLOSA RCHB. FIL.

Watercolour and bodycolour over graphite. 461 × 345 mm.
Bequeathed by Major the Hon. Henry Rogers Broughton,
2nd Lord Fairhaven, 1973. PD.406–1973.

Cornelius Durham was a portrait miniaturist who exhibited at Suffolk Street and the Royal Academy between 1827 and 1858. He was also a gifted flower painter and was commissioned by the keen amateur grower of orchids, John Day (1825–86), to draw his plants from 1862 onwards. Durham made three hundred drawings for Day for a fee of three pounds each. After Day's death the collection of drawings of orchids was sold to Jeremiah Colman of Gatton Park, Surrey.

Cattleya dolosa Reichenbach filius is an epiphytic orchid, the plant growing on another (usually a tree) without drawing nourishment from its host. A native of central Brazil, it is regarded sometimes as a variety of *Cattleya walkeriana*. A genus of the *Orchidaceae*, it is named in honour of William Cattley of Barnet (died 1832), a famous patron of botany and an ardent collector of rare plants. This drawing of Day's own specimen must have been made c.1872, when it is known to have flowered. An engraving of it is in *The Gardener's Chronicle* for 1876. There was an extreme interest in the cultivation of orchids between 1830 and 1850, reminiscent of tulipomania in Holland in the seventeenth century, which was superseded by fernmania towards the end of the nineteenth century. But amateurs like Day continued to cultivate orchids through the century. Their slightly sinister beauty had considerable impact on the Symbolists, and a heady description of their potency can be found in Huysmans' novel *A rebords* (*Against nature*). Epiphytic orchids are easier to grow than the terrestrial orchid and were thus more popular amongst amateur growers.

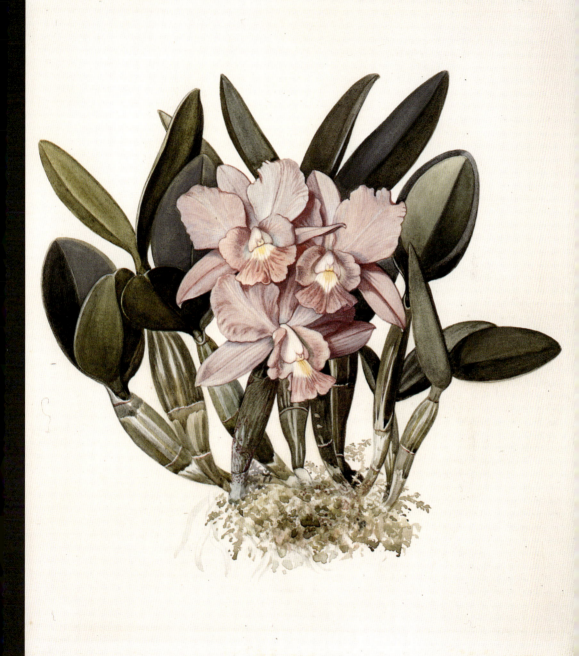

AUGUSTA INNES WITHERS

Active in London 1827–1865

—

DATURA ROSEI

Watercolour, bodycolour and gum arabic over traces of graphite.
397 × 254 mm. Inscribed in brown ink, on a separate piece of paper attached
to the old mount: 'Brugmansia S.A.', and in graphite: 'Mrs WITHERS'.
Bequeathed by Major the Hon. Henry Rogers Broughton,
2nd Lord Fairhaven, 1973. **PD.993–1973.**

Mrs Withers exhibited at the Royal Academy from 1829 to 1846, at Suffolk Street, with the New Watercolour Society and elsewhere until 1865. Loudon wrote in *The Gardeners' Magazine*, 1831, that 'It is due to Mrs Withers of Grove Terrace, Lisson Grove to state that her talents for teaching [botanical illustration] are of the highest order, as many of the plates in the *Transactions of the Horticultural Society* and the *Pomological Magazine* abundantly show.' In 1833 she was appointed Flower Painter in Ordinary to Queen Adelaide (wife of William IV), who became Queen Dowager on the accession of Victoria in 1837. Mrs Withers contributed to the *Illustrated Bouquet* (1857–63) and, with Miss Drake (active 1818–47) to James Bateman's *Orchidaceae of Mexico and Guatemala* (1837–41), which was dedicated to Queen Adelaide. She was a member of the Society of Lady Artists and resided in Fulham most of her active life.

The *Datura rosei* or Thorn Apple is a handsome species from Ecuador, closely related to the superficially similar *Datura sanguinea* from Peru. The inscription 'Brugmansia S.A.' attached to the label on the old mount is the original name given to this plant. Mrs Withers has created highlights in the foliage of the Datura by sparing the paper. Her sense of design is markedly dramatic, and her treatment of this beautiful flower emphasises its exoticism.

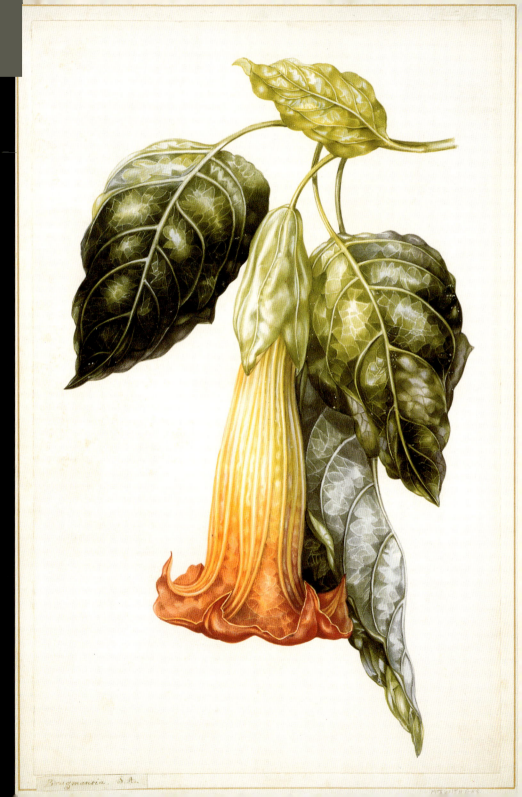

MRS WILLIAM DUFFIELD

Bath 1819–1914 London

—

FRUIT AND FLOWERS ON A
STRAW MAT IN A WINDOW FRAME

*Watercolour and bodycolour, a strip of unfaded pigment
around the edge gives the true colour range of the original. 347 × 486 mm.
Signed with the brush, lower right: 'M E Duffield'. Bequeathed by Major the Hon.
Henry Rogers Broughton, 2nd Lord Fairhaven, 1973.* **PD.393–1973.**

Mrs Duffield was born Mary Elizabeth Rosenberg, daughter of Thomas Elliott
Rosenberg and sister of Charles (see 57). She specialised in flower painting
and in 1834 was awarded a silver medal by the Society of Arts. She exhibited
regularly until 1912. In 1850 she married William Duffield (1816–63), a pupil
of the still-life painter, George Lance (1802–64), who was also a flower
painter. In 1861 she was elected a member of the (Royal) Institute of Painters
in Water Colours. She wrote a treatise on flower painting, *Art of flower painting*,
which was published in 1856 and went through several editions.

A bunch of grapes suspended from a vine lies behind a spray of Pelar-
gonium, with a Magnolia flower beside it. The bloom on the grapes has been
effectively conveyed by the artist's use of a stipple technique. The brilliance of
the original is no longer ascertainable as Mrs Duffield has used a red pigment
which has faded in the light. At the top the vine leaf still conveys some idea of
its original tonal contrast of green and red, but the Pelargonium has changed
from bright red to brown. The Magnolia is a blossom of *Magnolia grandiflora*,
native to the United States, which flowers from July to September. The pres-
ence of ripe grapes suggests that this was drawn in September. Despite the
change of colour due to exposure to light, this drawing is a fine example of
Mrs Duffield's ability as a painter.

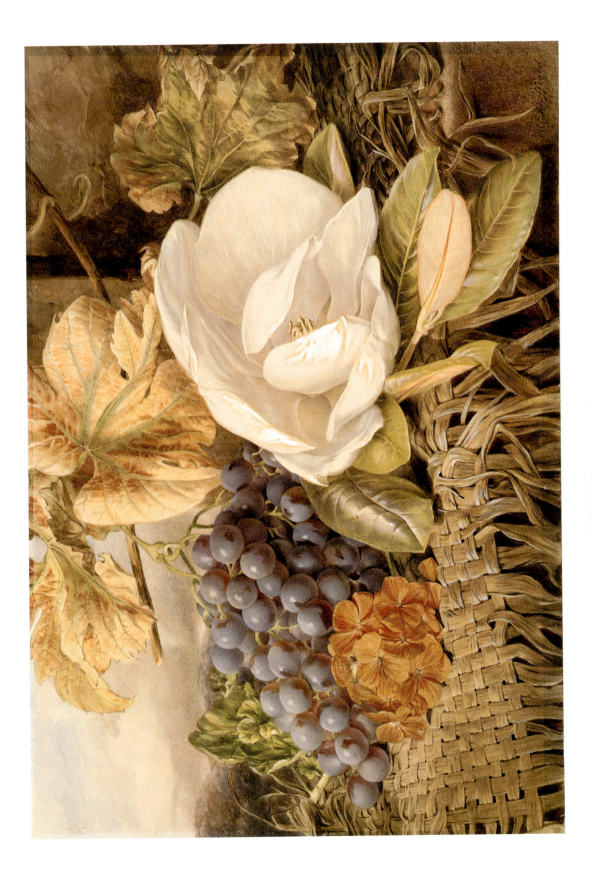

61

DOMINIQUE DUMILLIER

Active in Lyons 1857–1892

—

FLOWERING BRANCH OF A
SNOWBALL TREE WITH PARROT TULIPS

*Bodycolour on prepared paper. 498 × 436 mm. Signed with the brush,
lower left: 'Dominique Dumillier'. Bequeathed by Major the Hon. Henry
Rogers Broughton, 2nd Lord Fairhaven, 1973.* **PD.833–1973.**

Dumillier is said to have been a pupil of Jean-Marie Regnier (1815–86), who
had studied with Antoine Berjon (1754–1843), and his technique clearly
derives from them. He exhibited at the Lyons Salon from 1857 to 1892, and
was a designer for the Lyons silk manufacturers.

Viburnum opulus sterile (the 'snowball tree' or guelder rose), is a native of
Europe; it has heavily scented flowers which bloom in May and June.
Dumillier has made a spectacular composition, contrasting the neat, compact
heads of the viburnum with the flamboyant opulence of the 'broken' parrot
tulips. The use of a dark ground further emphasises the brilliance of colour of
the tulips, whose ragged ends are perfectly offset by the ball-like solidity of
the viburnum. The drawing is lit from the left and the greenish white of the
interior of the 'snowball' lower left is very subtle in its tonal contrast with the
opulent white of the exterior where the light falls directly on the blossom.

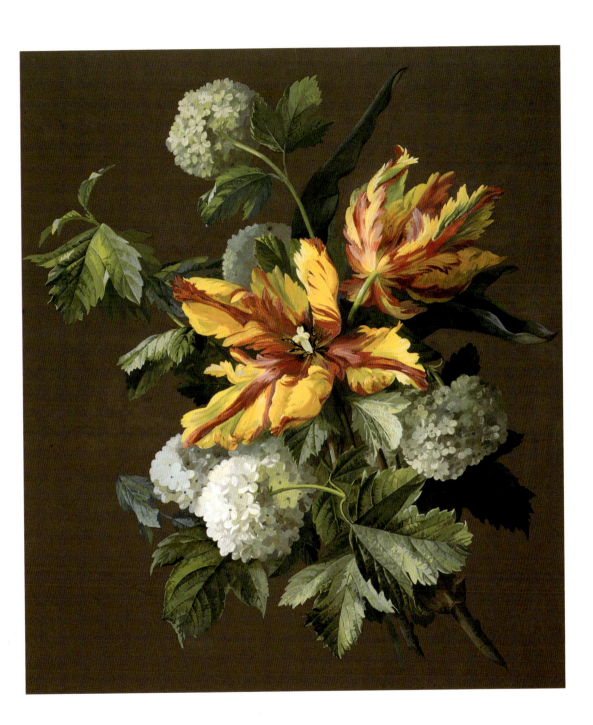

W. MUSSILL

Active in Austria 1872–1889

—

CLIMBING TEA ROSES
AND A HUMMING BIRD

Bodycolour and red ink on blue-grey paper. 634 × 486 mm.
Signed in red ink, lower right: 'W. Mussill'. Bequeathed by Major the
Hon. Henry Rogers Broughton, 2nd Lord Fairhaven, 1973.
PD.831–1973.

Mussill has a flamboyant technique, which displays bodycolour or 'gouache' to its most exuberant effect. He is said to be Austrian, but may come from Hungary. One drawing in the Fitzwilliam of water-lilies is inscribed 'Chatsworth', so it is possible that he visited England in 1879. In his drawings he goes for big effects and his work is highly characteristic of Central Europe at the end of the nineteenth century.

Hybrid tea roses are the successors to the hybrid perpetuals, the hardy roses which were so popular in Victorian times, descendants of the Portland, Bourbon and China roses. Climbing tea roses are less vigorous than those derived from species roses, but are suitable for growing over pillars, arbours, walls, pergolas, fences and screens. The particular roses drawn here have not been identified, and may no longer be grown, but the yellow buds, centre right, resemble 'Maréchal Niel'.

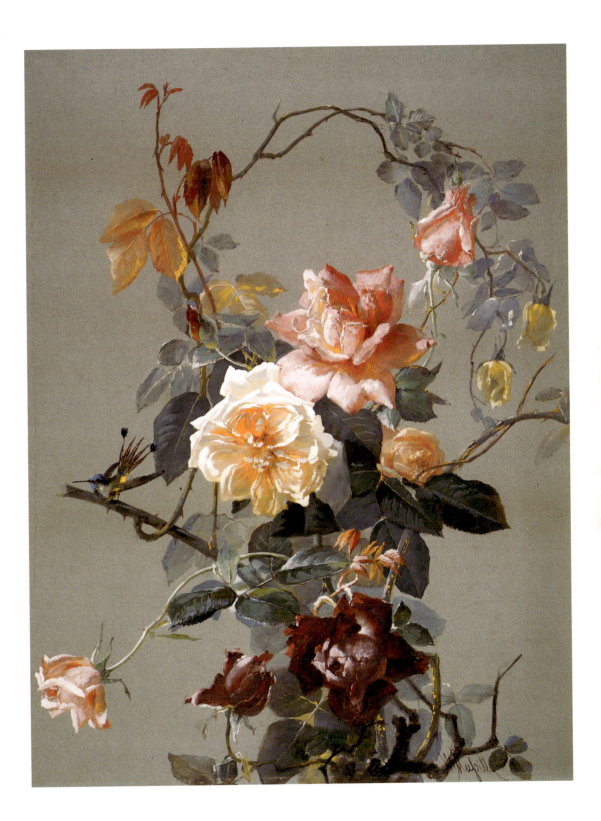

RAYMOND CHARLES BOOTH

Born Leeds 1929

●

ANTIRRHINUM

Oil on paper. 505 × 312 mm. Signed in graphite,
lower right: 'R.C.Booth/1953'. Bequeathed by Major the Hon.
Henry Rogers Broughton, 2nd Lord Fairhaven, 1973.
PD.208–1973.

Raymond Booth trained at the Leeds College of Art. His first botanical draw-ings were made in a sanitorium where he was recovering from tuberculosis. He has exhibited at the Royal Horticultural Society and at Walker's Galleries in Bond Street and with The Fine Art Society. He is as well known as a naturalist as a botanist, and although he has an international reputation he rarely leaves his native Yorkshire. With Don Elick he published *Japonica Magnifica*, 1992.

The *Antirrhinum* is better known by the popular name of 'snapdragon'. A genus of forty-two species of annuals, perennials and a few sub-shrubs. The most valuable garden species is that depicted here, the short-lived, woody-based hardy perennial *Antirrhinum majus*, which is native to the Mediterranean. Booth has stressed the formality of the plant, not an aspect of it which is particularly apparent in nature. The specimen he has painted has perfectly balanced foliage, splendidly offsetting the flowering spike.

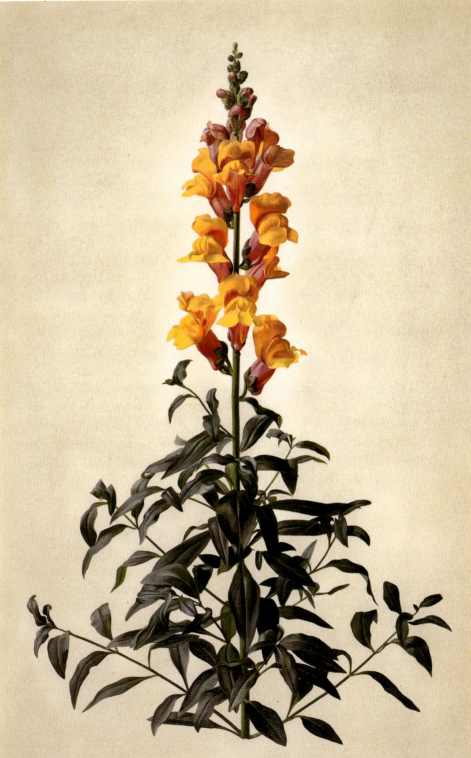

R.C.Booth
1953

MARGARET STONES

Born in Melbourne, Australia, 1920

•

MAGNOLIA CAMPBELLII

Watercolour over traces of graphite. 513 × 510 mm.
Signed in graphite on a bud, left of centre: 'MARGARET STONES';
inscribed in graphite, lower left: 'Magnolia campbellii subsp campbellii';
inscribed and dated in graphite, lower right: 'Cult. RBG Kew,
March 15 1989'. Given by John McIlhenny, 1989.
PD.3–1989.

Margaret Stones was born in Melbourne, Australia, and studied at Swinburne Technical College and the National Gallery School in Melbourne. She began to concentrate on botanical drawing when, confined to bed by a long illness, she drew the flowers that were placed beside her. In 1951 she left Australia for London and began to study both botany and botanical drawing at the Royal Botanical Gardens, Kew. In 1956 she began her long association with *Curtis' Botanical Magazine*, for which she has made more than 400 drawings. In addition to Curtis she has been involved with two long-term projects, *The endemic flora of Tasmania* (1967–78) and *The native flora of Louisiana* (1976–87). Honours include the MBE (1977) and the Membership of the Order of Australia (1988). She has won two medals from the Royal Horticultural Society (1976 and 1986), and has honorary doctorates from Louisiana State University and the University of Melbourne. She lives and works in Kew.

Magnolia campbellii is native to the Himalayan region. It grows to a height of thirty metres and was named by Sir Joseph Hooker for his friend Dr Archibald Campbell. Growing in the Himalayan forests from Nepal to the Chinese province of Yunnan, it flowers while leafless. This drawing was done from a branch taken from the uppermost section of a tree at Kew. Because of the mildness of the winter of 1988/9 the magnolia blossom was almost over when Miss Stones returned to England from Australia early in March 1989. Margaret Stones is a fitting artist with which to close this Handbook as she combines botanical accuracy with a remarkable sense of design, which looks back to the example of her great predecessors, George Ehret, James Sowerby and Redouté, showing that a great tradition continues.